Port Colborne Ontario Book 1 in Colour Photos, Saving Our History One Photo at a Time

Photography
by Barbara Raué
2016

Series Name:
Cruising Ontario

Book 167: Port Colborne Book 1

Cover photo: 326 Catharine Street, Page 45

Series Name: Cruising Ontario
The Authority on Saving Our History One Photo at a Time in colour photos

Books Available in Alphabetical Order:
Aberfoyle, Acton, Alton, Amherstburg, Ancaster, Arthur, Aylmer, Ayr, Bloomingdale, Brantford, Burlington, Caledon, Caledonia, Cambridge, Clifford, Conestogo, Delhi, Dorchester to Aylmer, Drayton, Drumbo, Dundas, Eden Mills, Elmira, Elora, Essex, Fergus, Guelph, Hagersville, Hamilton, Hanover, Harriston, Hespeler, Jarvis, Kingston, Kingsville, Kitchener, Linwood, Listowel, London, Lucknow, Mono, Mount Forest, Neustadt, New Hamburg, Niagara-on-the-Lake, Oakville, Orangeville, Orillia, Owen Sound, Palmerston, Peterborough, Petrolia, Port Elgin, Preston, Rockwood, Sarnia, Seaforth, Sheffield, Shelburne, Simcoe, Southampton, St. Jacobs, St. Marys, St. Thomas, Stoney Creek, Stratford, Thamesford, Tillsonburg, Waterdown, Waterford, Waterloo, Welland, Wellesley, Windsor, Wingham, Woodstock

Book 125-127: Woodstock
Book 128: Thamesford
Book 129-132: St. Marys
Book 133-136: Sarnia
Book 137: Petrolia
Book 138-139: Welland
Book 140-145: Kingston
Book 146-149: Ottawa
Book 150-151: Midland
Book 152: Penetanguishene
Book 153: Kemptville
Book 154: Cornwall
Book 155: Mariatown to Maitland
Book 156: Morrisburg
Book 157: Brockville
Book 158: Merrickville
Book 159: Smiths Falls
Book 160: Portland, Newboro
Book 161: Westport & Area
Book 162: Perth
Book 163-166: Belleville
Book 167-168: Port Colborne
Book 169: Erin in Colour
Book 170: Goderich in Colour
Book 171: Sault Ste. Marie

Other Books by Barbara Raue

Coins of Gold

Arrows, Indians and Love

The Life and Times of Barbara
Volume 1: Inventions That Have Enhanced My Life
Volume 2: Entertainment That I Have Enjoyed
Volume 3: East Coast Trips
Volume 4: Olympics Have Always Intrigued Me
Volume 5: Wonders of the World
Volume 6: Caribbean Cruises We Have Enjoyed
Volume 7: Animals
Volume 8: Storms and Other Major Disasters in My Lifetime
Volume 9: Wars, Terrorist Attacks and Major Disasters

The Cromwell Family Book

Laura Secord Discovered

Daddy Where Are You?

Montana Series
Book 1: Montana Dream
Book 2: Life on the Montana Frontier
Book 3: Montana to Boston and Back
Book 4: Montana Sons Go to War
Book 5: Montana Sons Return From War

Visit Barbara's website to view all of her books
http://barbararaue.ca

Table of Contents

King Street................................Page 6

Charlotte Street........................Page 32

Adelaide Street.........................Page 36

Fielden Avenue........................Page 37

Erie Street.................................Page 37

Killaly Street West....................Page 40

Catharine Street.......................Page 41

Park Street................................Page 49

Clarence Street........................Page 51

Carter Street.............................Page 52

West Street...............................Page 55

Elm Street.................................Page 64

Architectural Terms.................Page 66

Building Styles.........................Page 69

Port Colborne is a city on Lake Erie, at the southern end of the Welland Canal. The original settlement, known as Gravelly Bay after the shallow, bedrock-floored bay upon which it sits, dates from 1832 and was renamed after Sir John Colborne, a British war hero and the Lieutenant Governor of Upper Canada at the time of the opening of the southern terminus of the First Welland Canal in 1833 when it was extended to reach Lake Erie.

Port Colborne was one of the hardest hit communities during the blizzard of 1977. Thousands of people were stranded when the city was paralyzed during the storm.

Maritime commerce, including supplying goods to the camps for the laborers who worked on the first canal, ship repair and the provisioning trade, was, and still is, an important part of Port Colborne's economy. Port Colborne was a heavily industrial city throughout most of the early twentieth century. A grain elevator, two modern flour mills, a Vale nickel refinery, a cement plant and a blast furnace were major employers. Several of these operations have closed over the past thirty years, while others employ a lot less residents due to modernization and cutbacks.

Port Colborne has been successful attracting agro-business operations which process corn into products such as sweeteners and citric acid. The economy has gradually shifted towards tourism and recreation, taking advantage of the scenic beauty of the lakeshore.

The Port Colborne Historical and Marine Museum, located near the centre of town, is a resource for local history and archival research. In addition to a collection of historic buildings and artifacts, it opened up the "Marie Semley Research Wing" to foster research into local history; it was named to commemorate the long-standing efforts of a local resident who devoted hours to the museum.

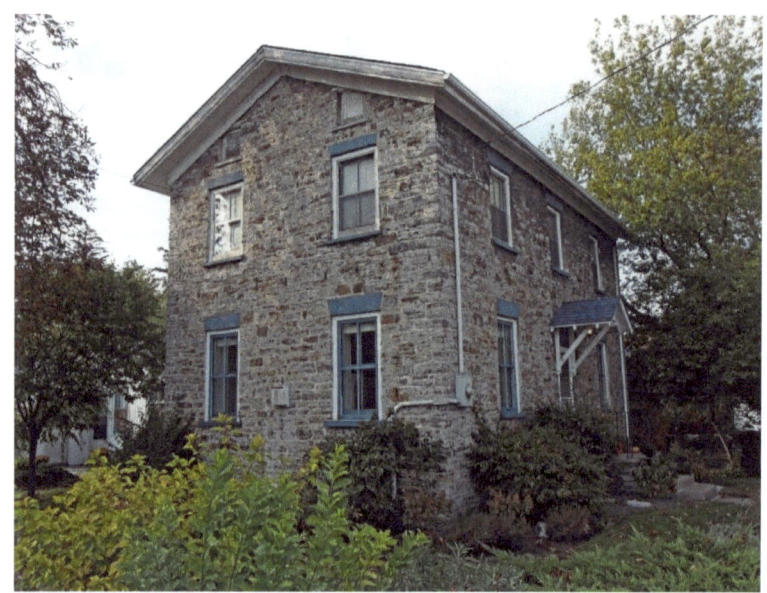

44 King Street – 1835 – one of only a few stone structures in Port Colborne – The walls, made of limestone taken from the Welland Canal, are more than half a metre thick. The Georgian style of architecture is evident in the balanced three-bay-façade and centred doorway.

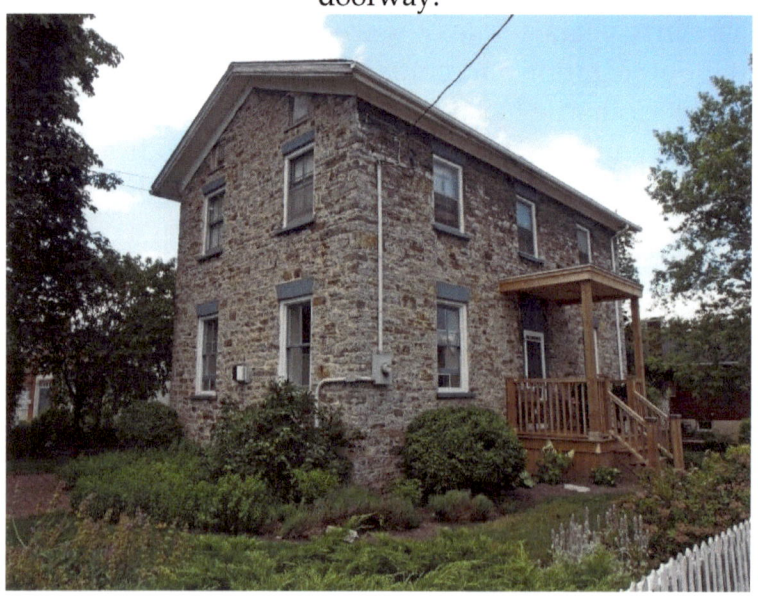

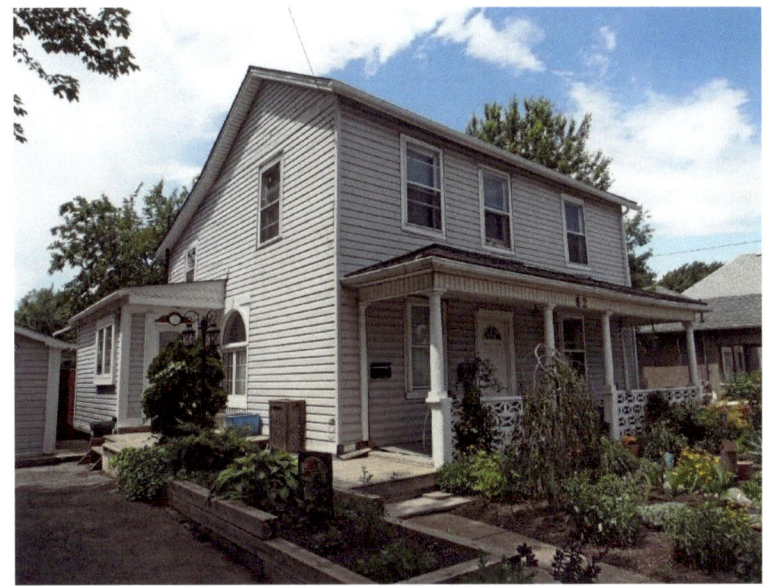

62 King Street

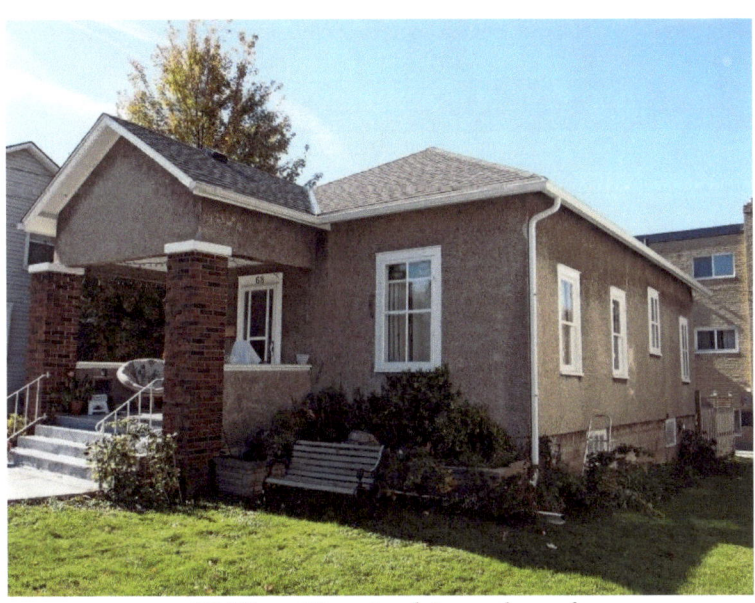

68 King Street – hipped roof

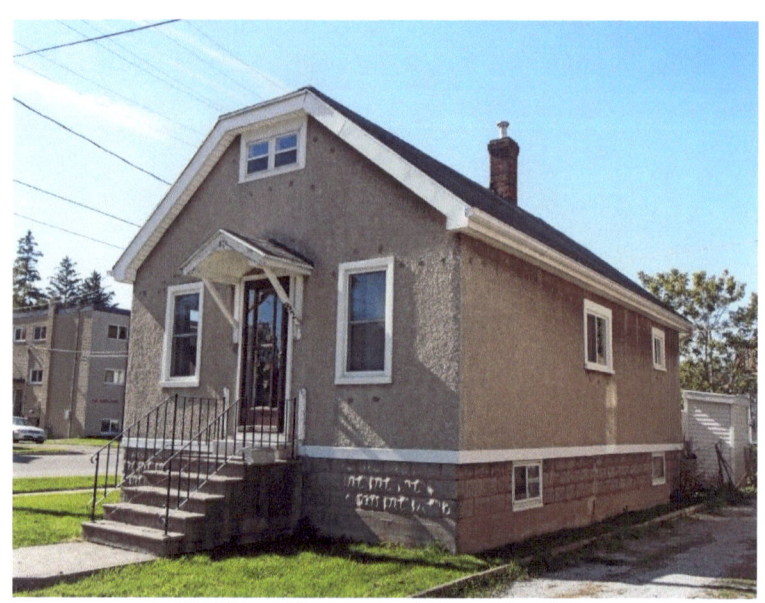

82 King Street – chipped gable

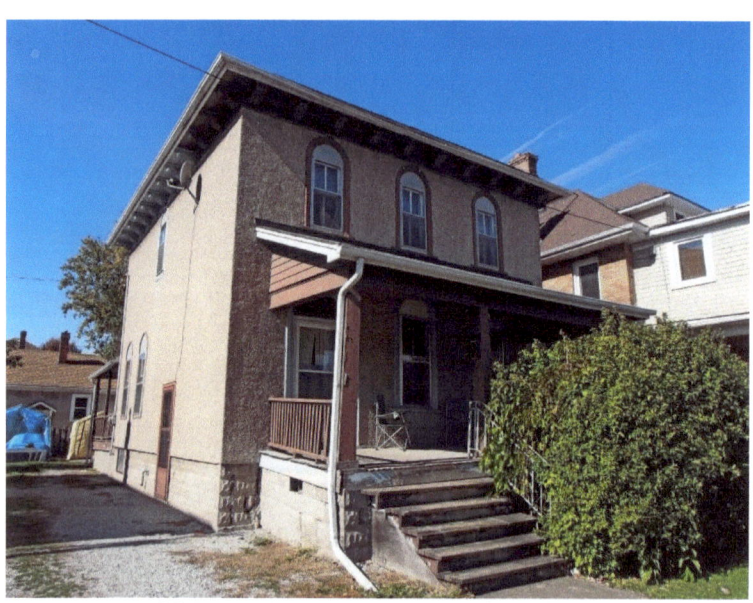

88 King Street – cornice brackets

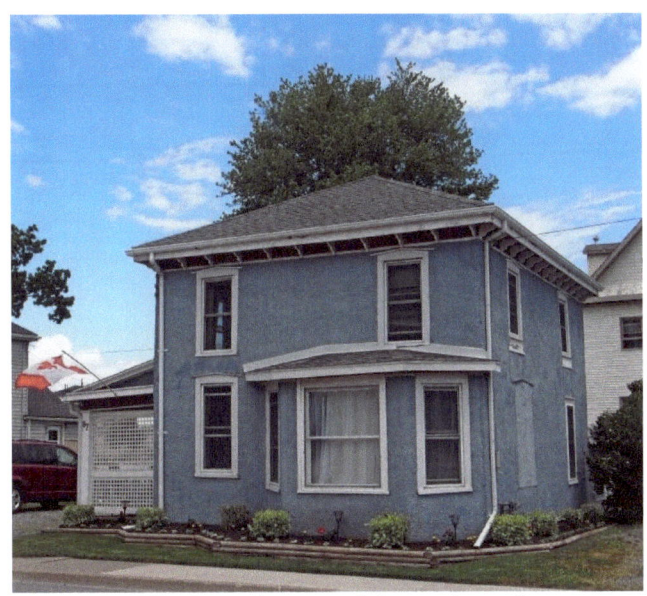

87 King Street – hipped roof

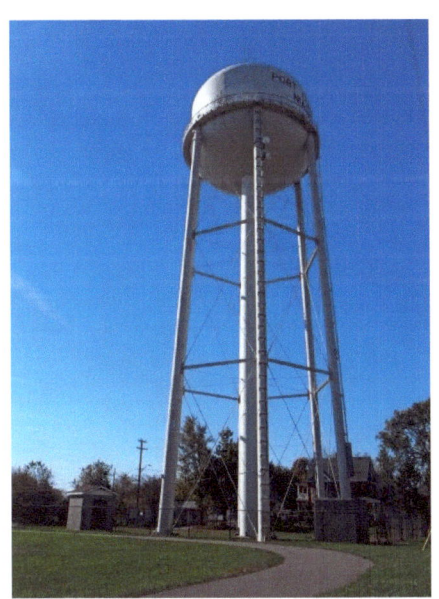

Water Tower

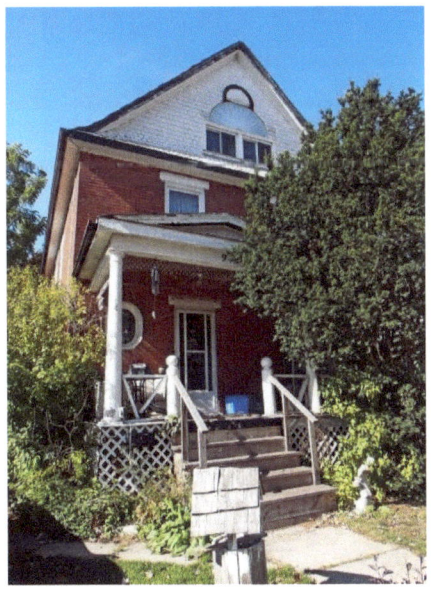

94 King Street

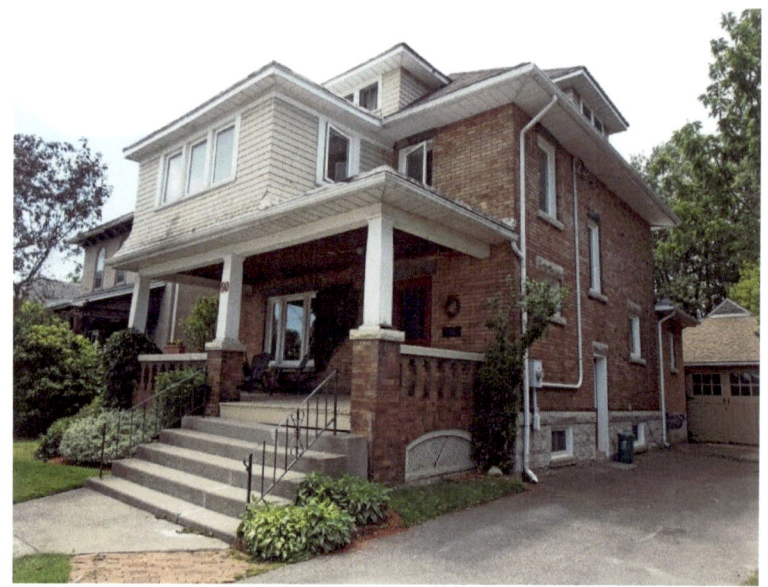
90 King Street – hipped roof with dormers

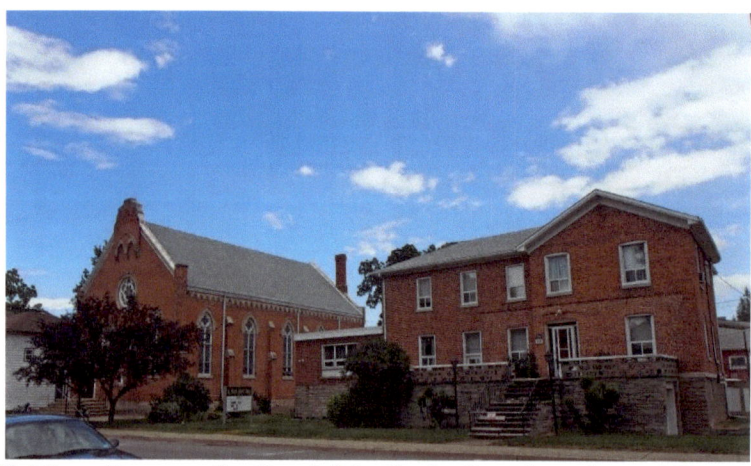
123 King Street – St. Patrick's Catholic Church and Rectory

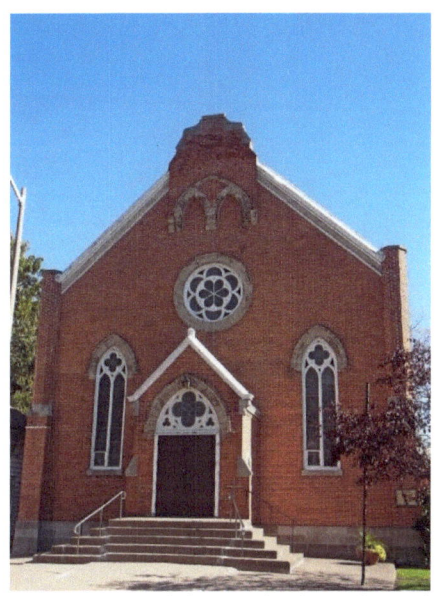

123 King Street – St. Patrick's Catholic Church – 1879 – steep roof and narrow, lancet windows of Neo-Gothic architecture – rose window

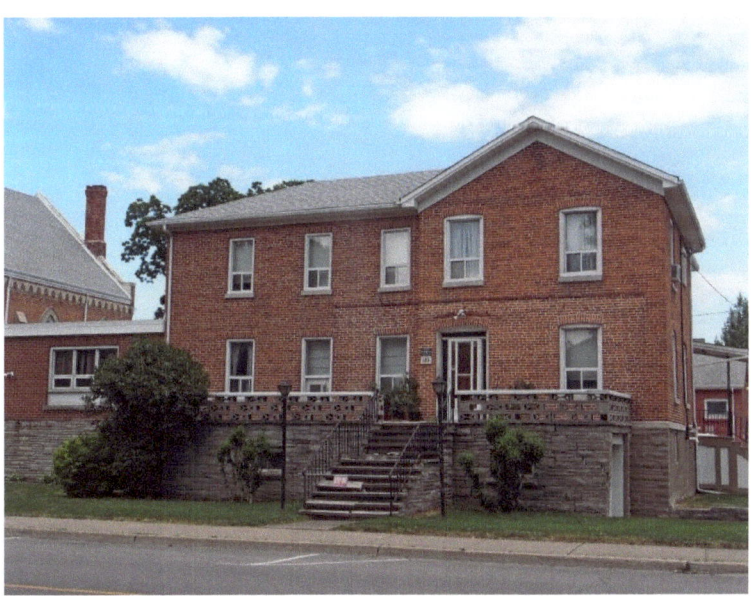

The rectory was built in 1871 and still serves the parish.

150 King Street – dormer in attic, wraparound veranda

King Street – cornice brackets, corner quoins

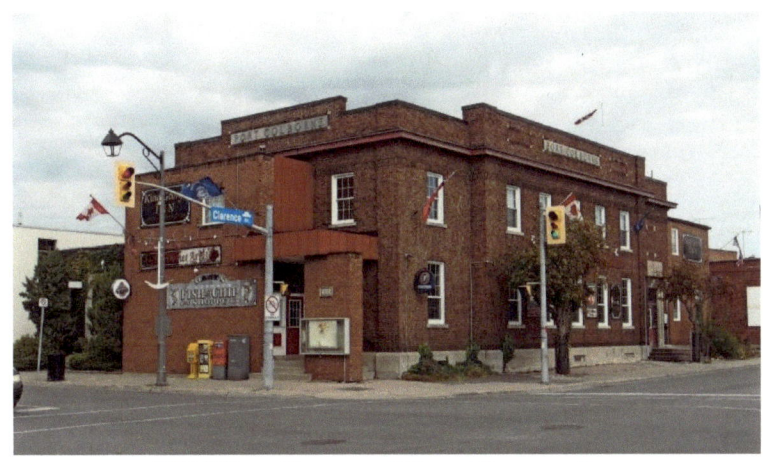

239 King Street – King George Inn

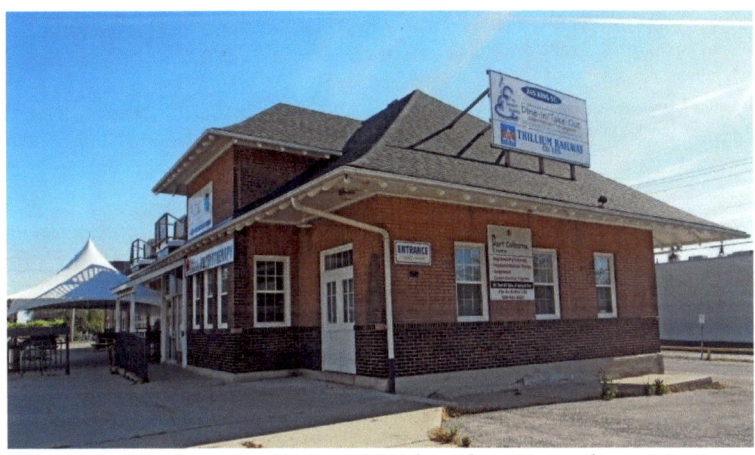

265 King Street – Built in 1925 by the Canadian National Railway, this brick structure served as a passenger and freight station. It was the terminus of the Niagara, St. Catharines and Toronto Railway which operated a trolley between Port Dalhousie and Port Colborne. It has a bell cast roof with exposed rafters, which creates a decorative eaves line.

280 King Street – Historical and Marine Museum

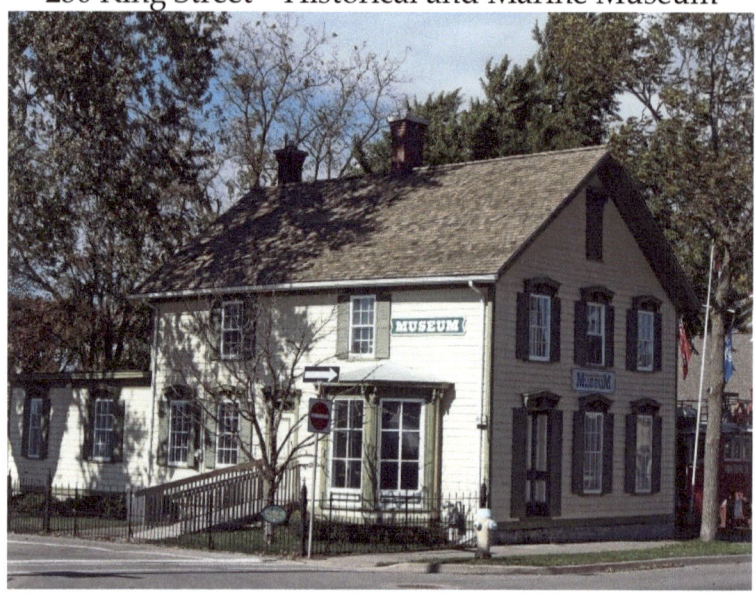

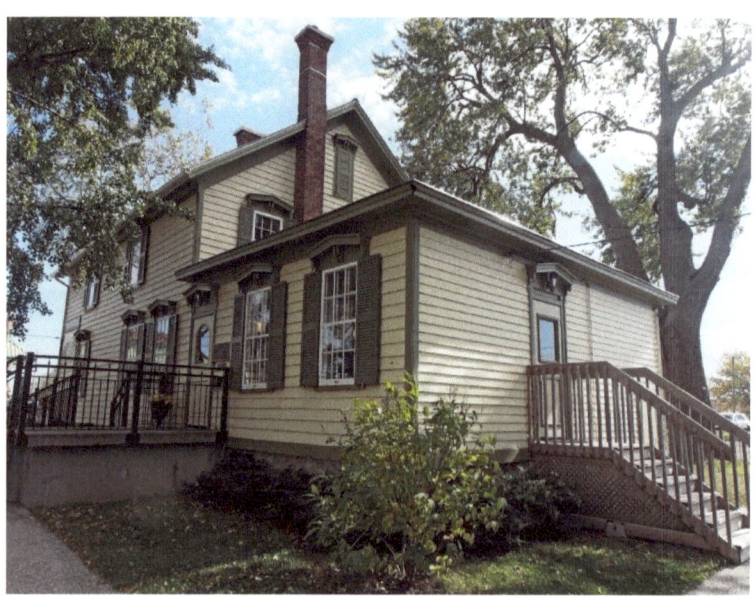

Built in 1861 by John Williams, of United Empire Loyalist stock, the frame house with small window panes, slatted shutters and pediments over the windows shows characteristics of Georgian Revival style architecture. It was owned by John Williams' daughter, Arabella, until her death in 1950, when the entire block of property was bequeathed to the City of Port Colborne. In 1974, the house was restored and converted into the Historical and Marine Museum.

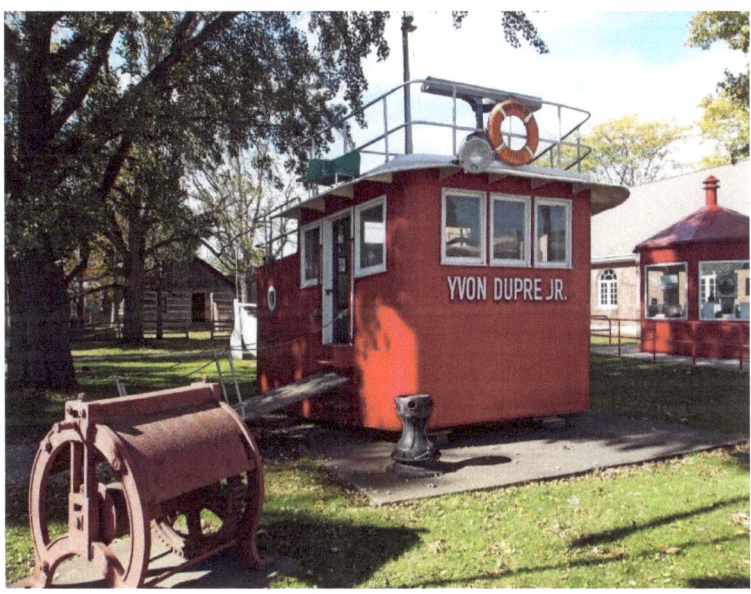

Wheelhouse – 1946; Lighthouse to back right

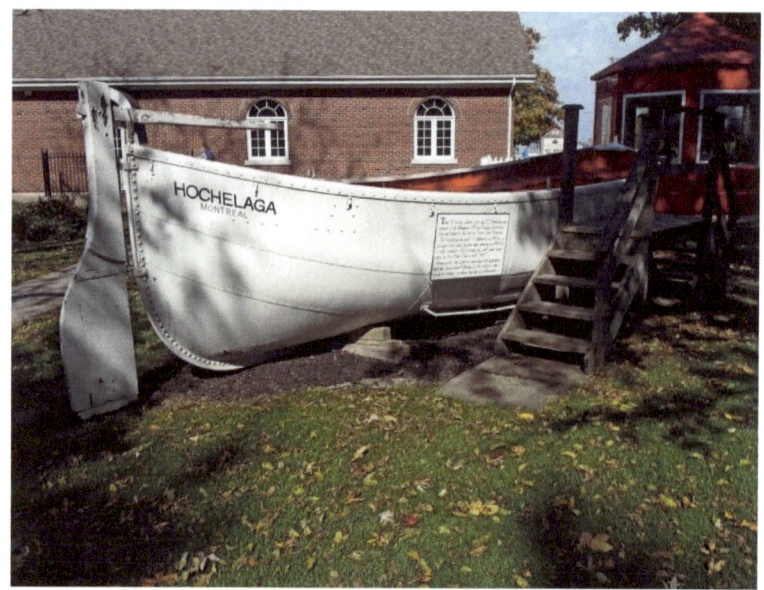

This is a 50-person lifeboat from the Hochelaga which was built in Collingwood in 1949 as a bulk freighter. The Hochelaga carried ore, coal, grain and stone on the Great Lakes until 1987.

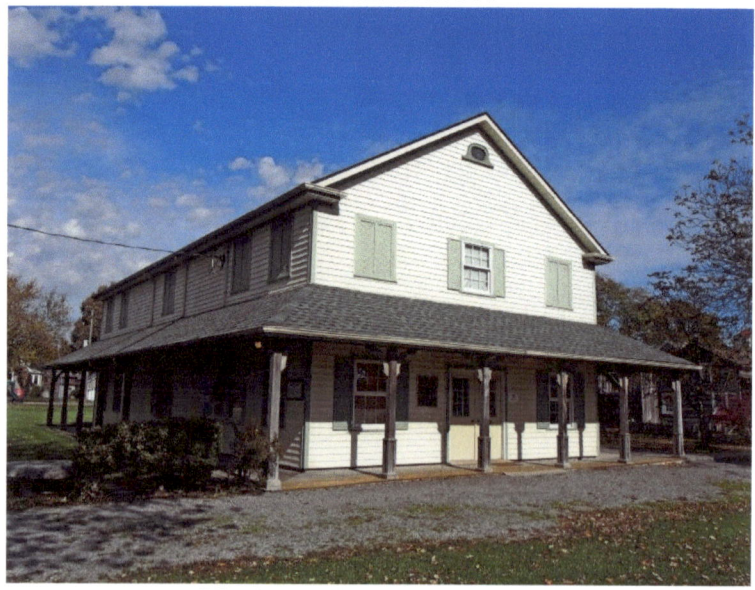

Heritage Resource Centre

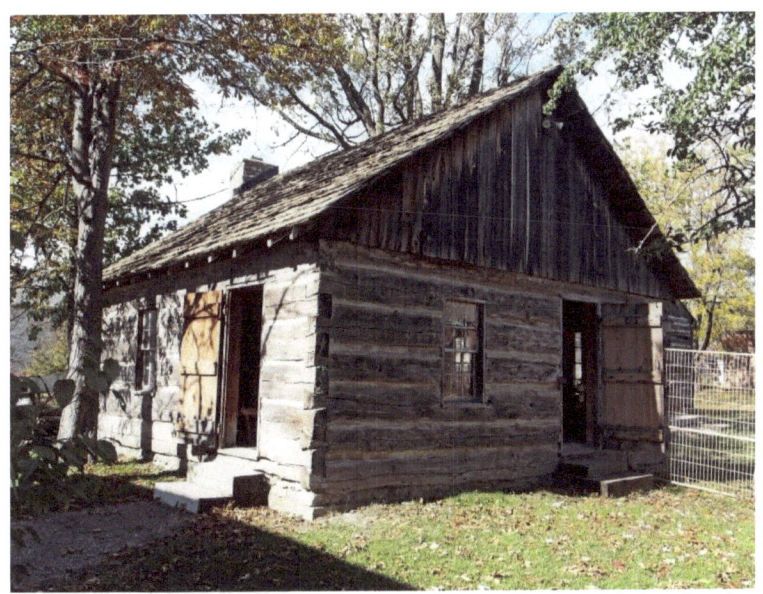

Log Schoolhouse – 1835 – Pennsylvania Mennonite heritage

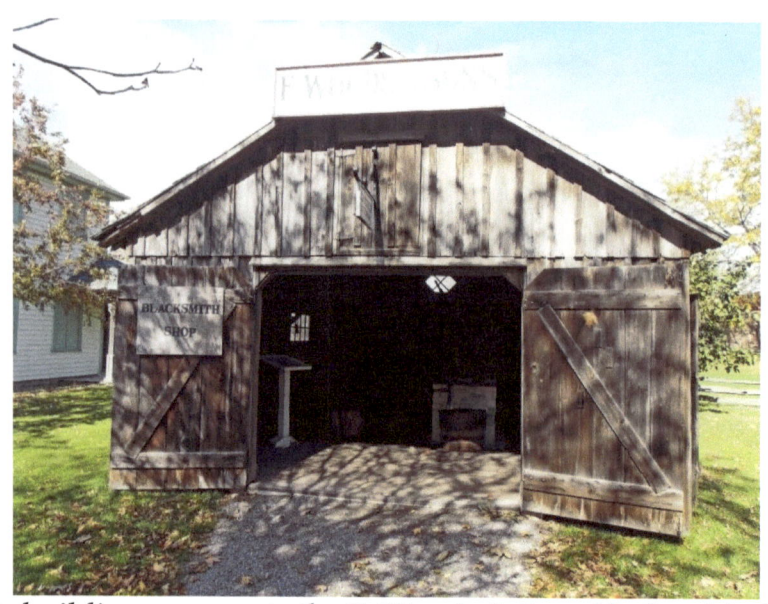

This building represents the F. Woods & Sons blacksmith shop which was founded in 1870; it served the community and marine trades. Iron work on the sailing ships and steamers on the canal was repaired, and horses that towed the vessels through the waterway were shoed.

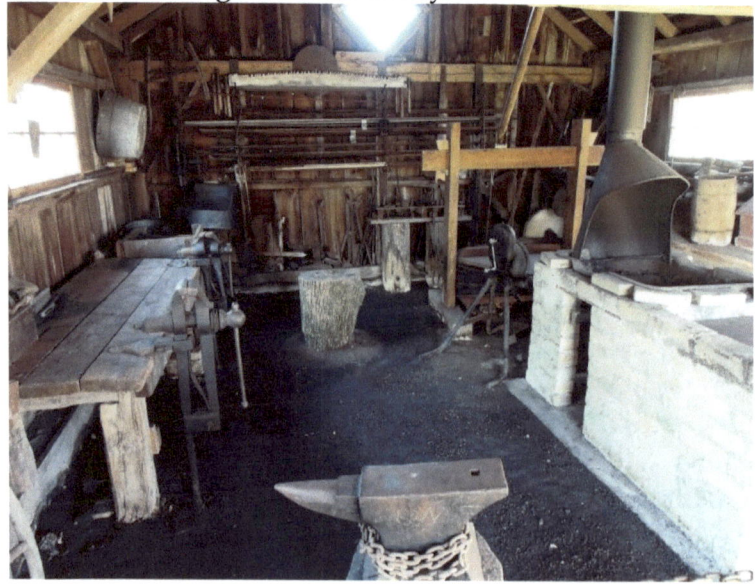

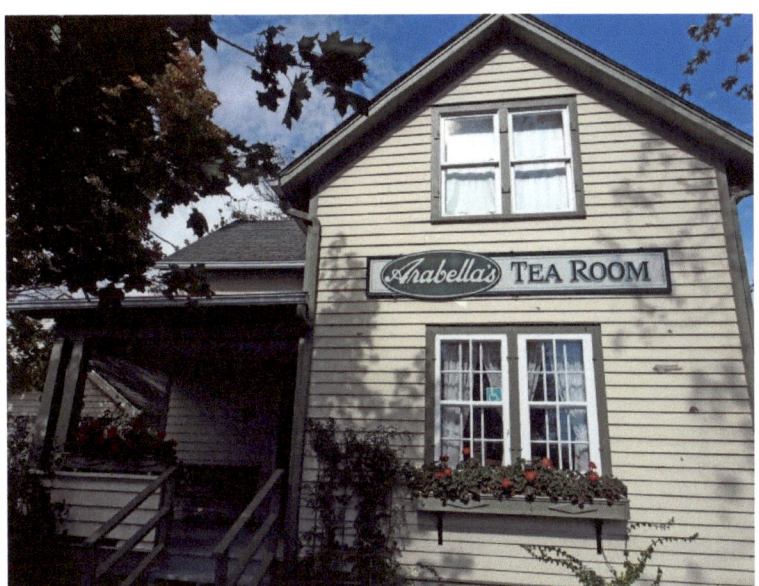

Arabella's Tea Room – 1915

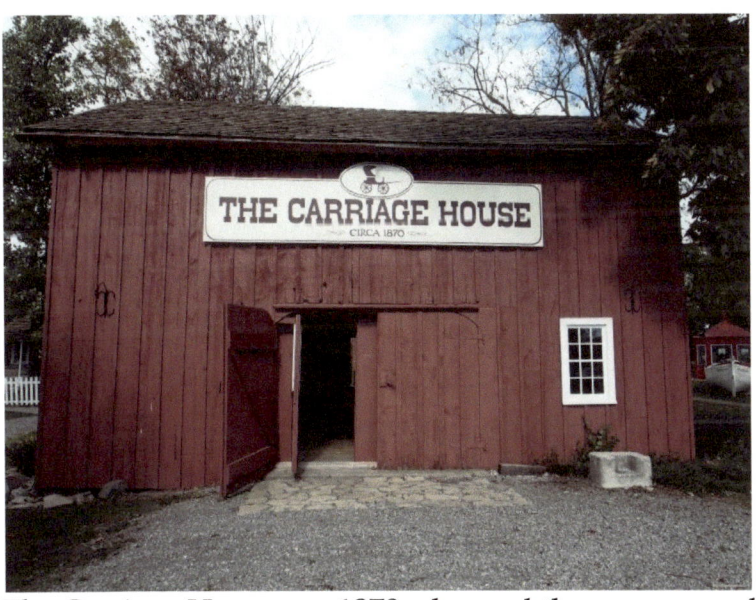

The Carriage House – c. 1870 – housed the wagons and carriages of the Williams' family

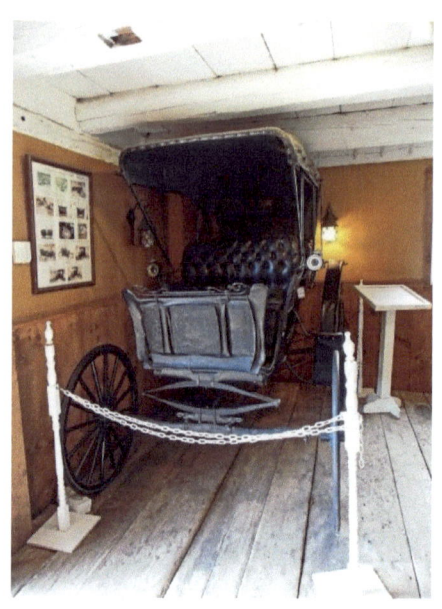

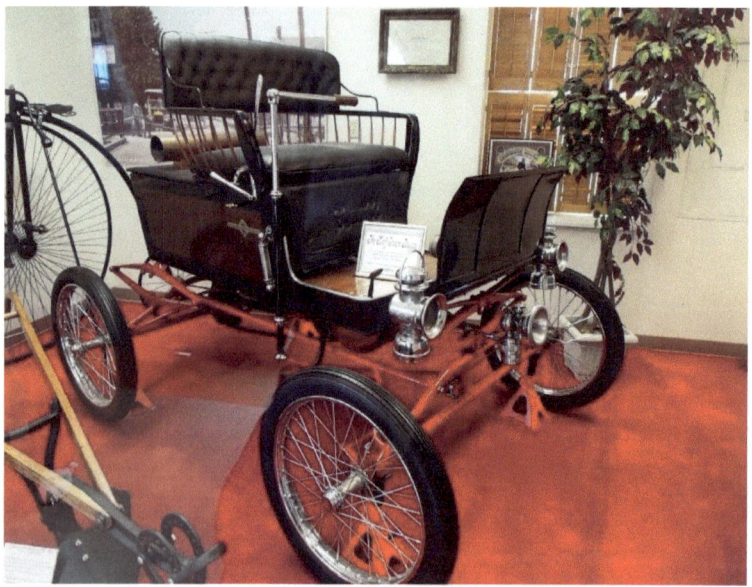

The 1901 Neff Steam Buggy, one of Canada's oldest existing automobiles, built by Benton Neff at the Neff Foundry in Humberstone which is part of Port Colborne today.

Wagon wheels

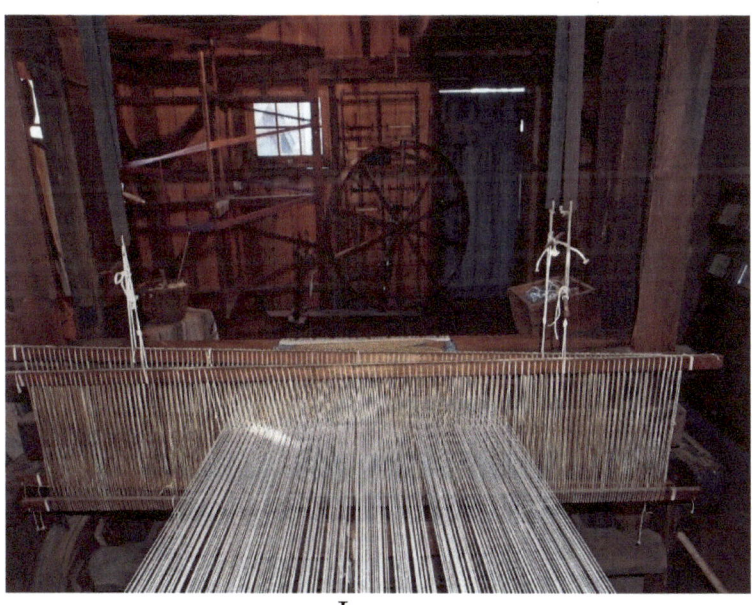
Loom

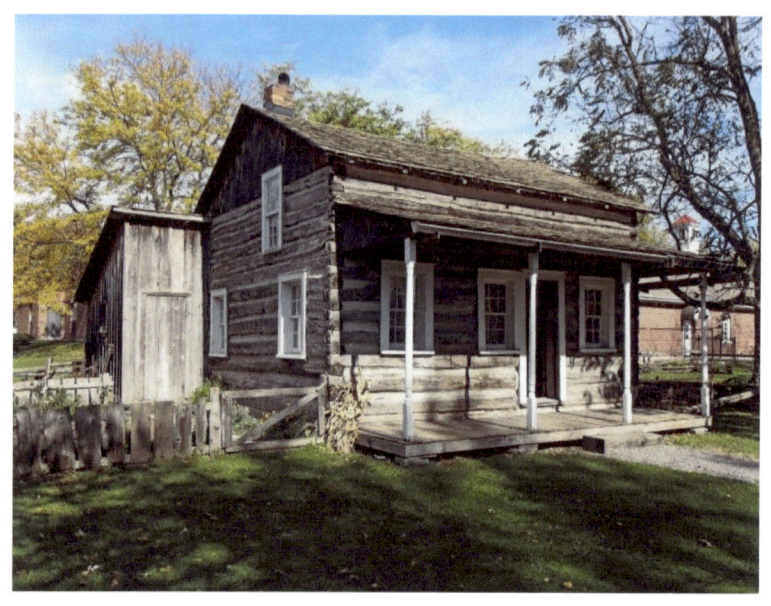

Log House – 1850 – Pennsylvania Mennonite heritage

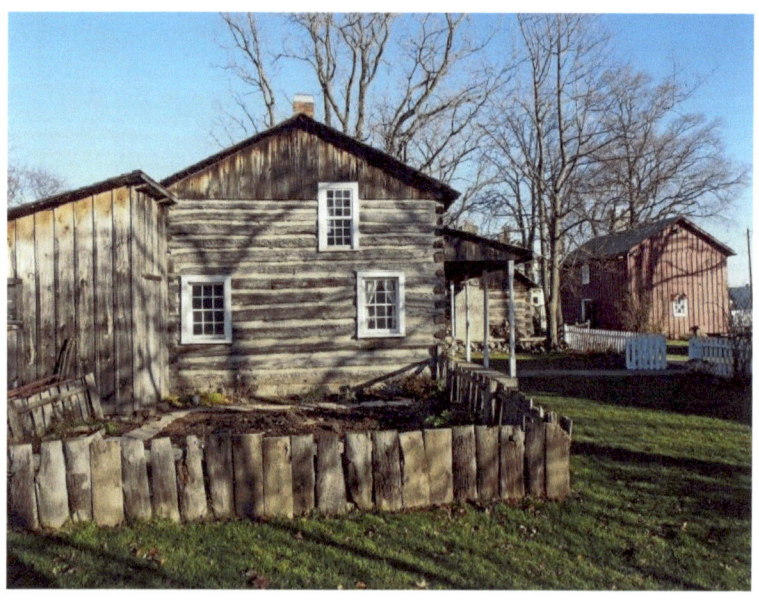

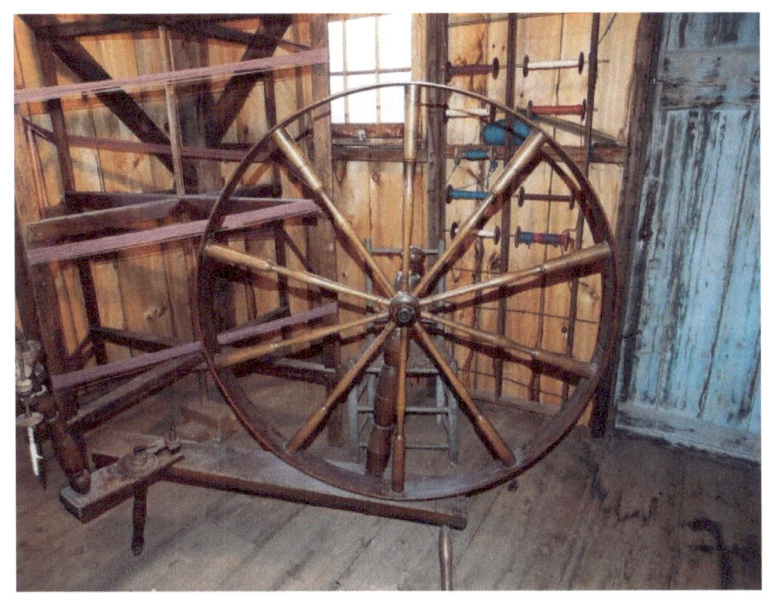

Spinning wheels

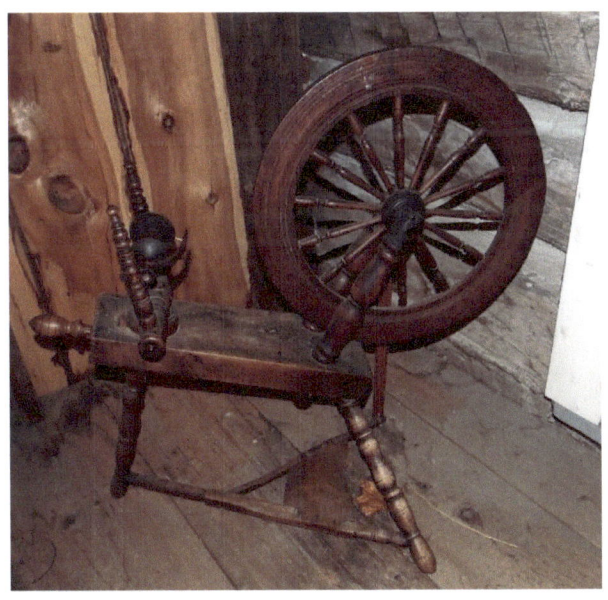

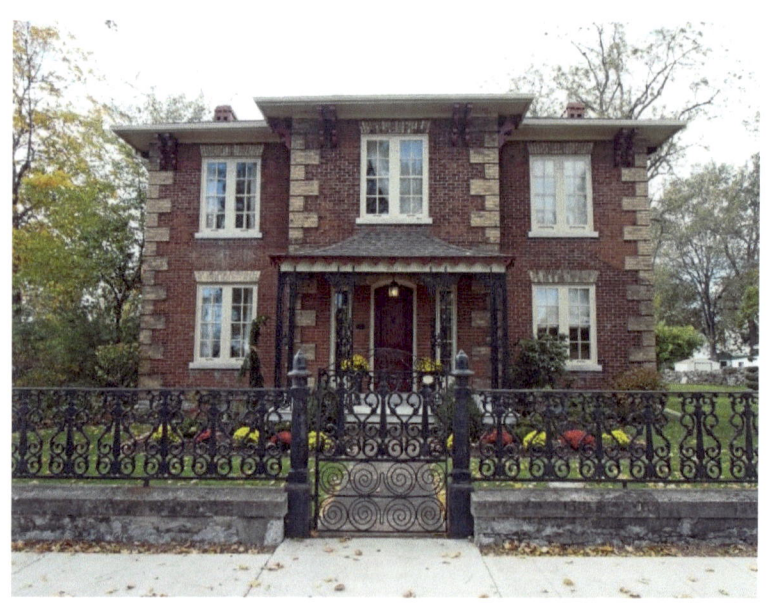

322 King Street – Ingleside – It was built in 1867 for Charles H. Carter and occupied by the Carter family for 118 years, including Port Colborne's first mayor, Dewitt Carter. The two-storey structure has projecting eaves supported by paired cornice brackets and corner quoins in dichromatic brick characteristic of Italianate architecture. Its rectangular plan with projecting frontispiece and hipped roof indicate it is a version of a house plan popularized by the magazine "The Canada Farmer" in 1865. The grounds are surrounded by a locally produced cast iron fence.

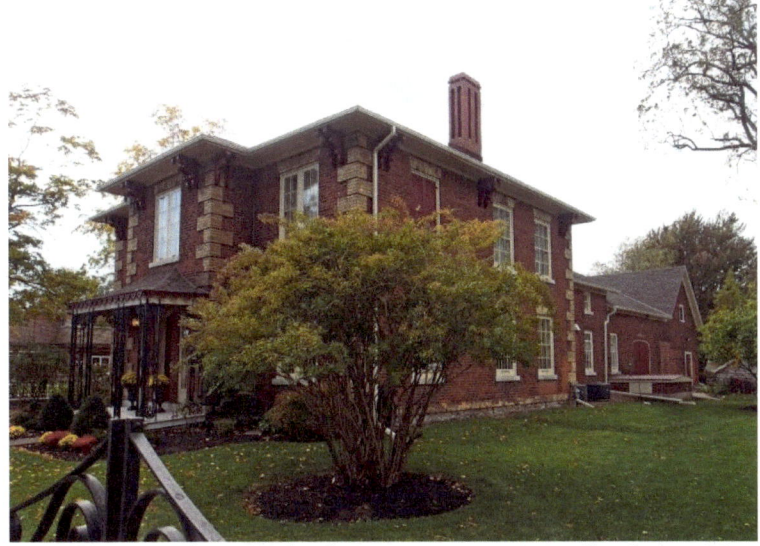

322 King Street – The attached garage was originally the stable, with the carriage house connecting it to the main structure. The gardens are laid out in an early style and feature heritage roses. The grounds are surrounded by a locally produced cast iron fence, one of the last remaining in Ontario.

The original ice house and smoke house are still standing in the side yard.

354 King Street – Palladian window in gable, two-storey verandah, two-storey bay window

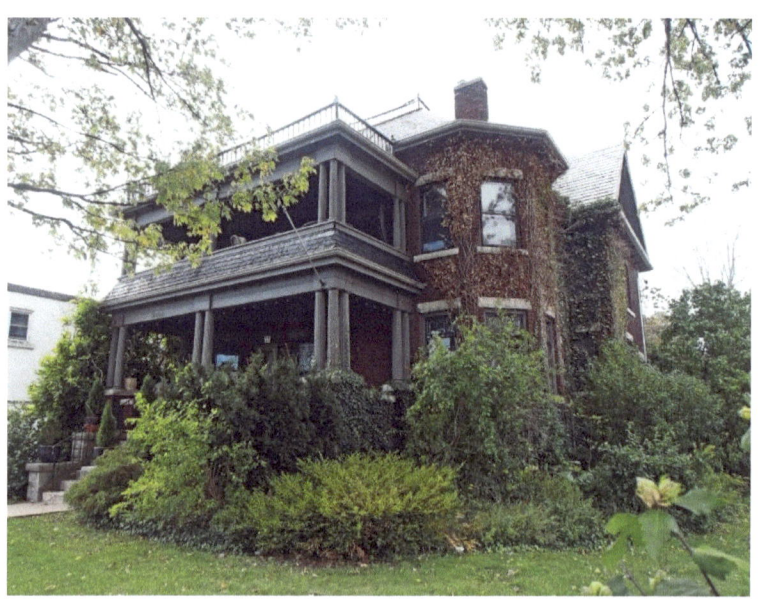

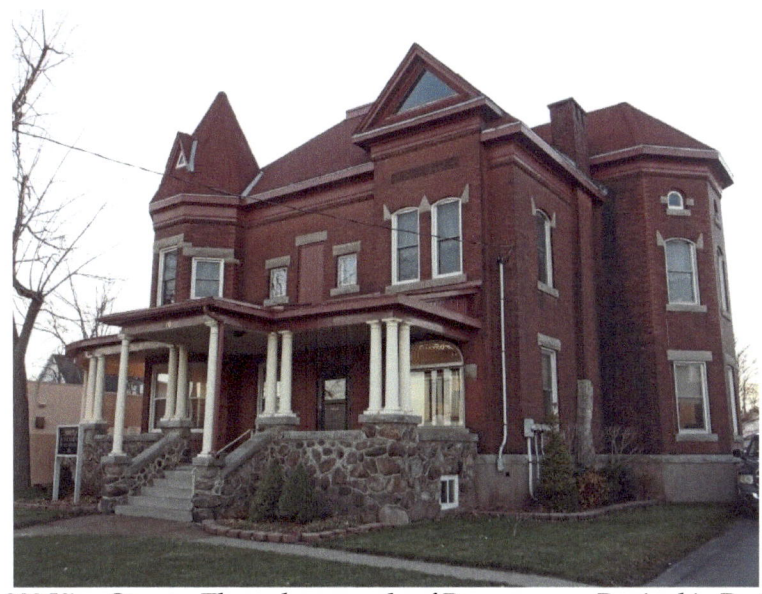

380 King Street – The only example of Romanesque Revival in Port Colborne, this home was built about 1907 for Thomas Euphronius Reeb. The Romanesque is shown in its dark red brick and heavy cut stone window sills and lintels. The Queen Anne influence is evident in the octagonal tower with lard "band shell" verandah, wide round-arched first floor window with etched leaded glass and a line of terra cotta tiles with egg and dart motif under the eaves.

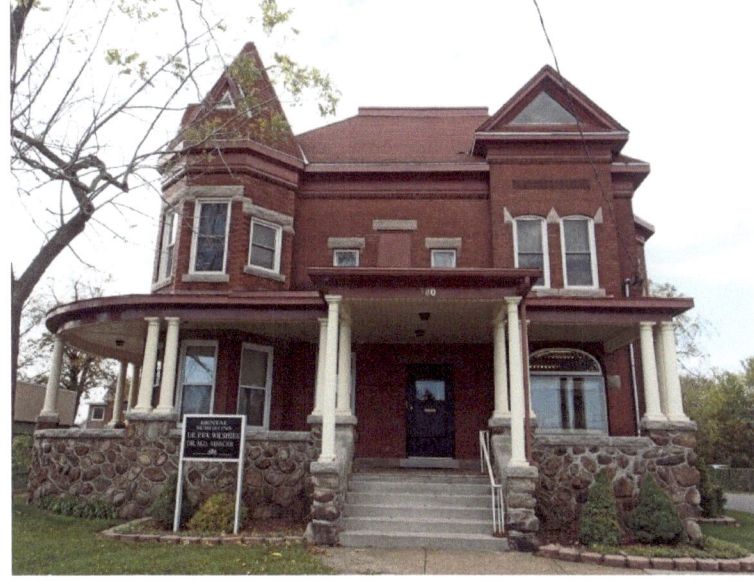

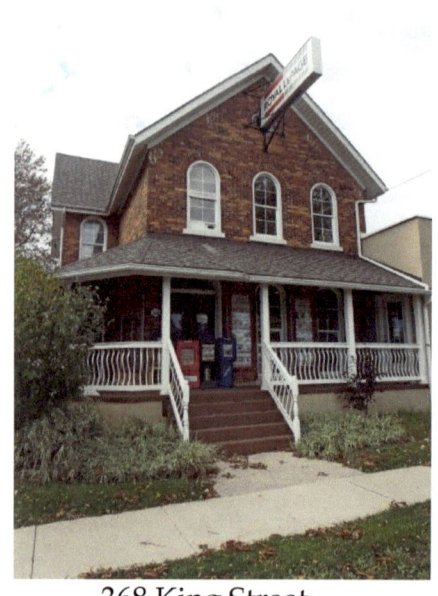 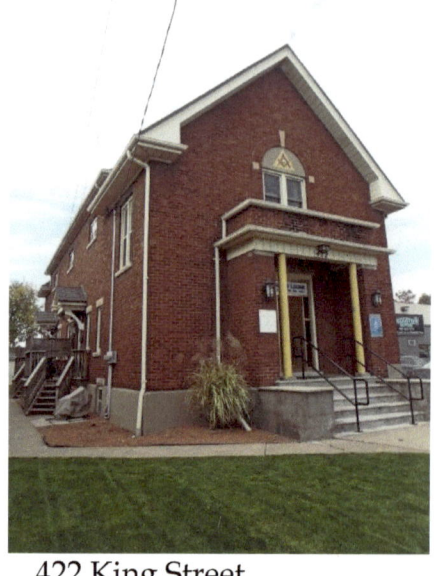

368 King Street 422 King Street
Gothic

King Street

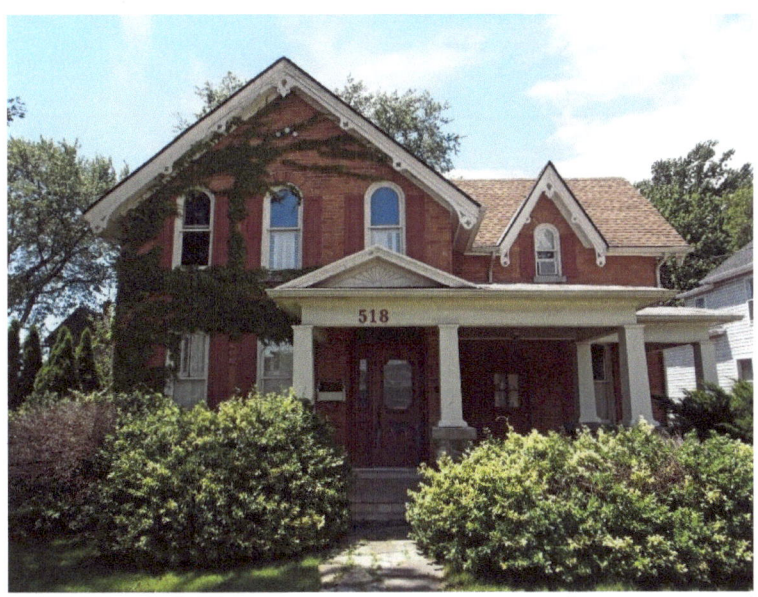

518 King Street – c. 1880 – The Ott House was constructed for Frederick J. Quinn, and was later owned for about thirty years by Herman Ott, a member of Humberstone Village Council. It has an eclectic mix of late Victorian styles with lacy verge board on the Gothic Revival gables, round-headed windows of the Italianate, and a doorcase of Georgian character.

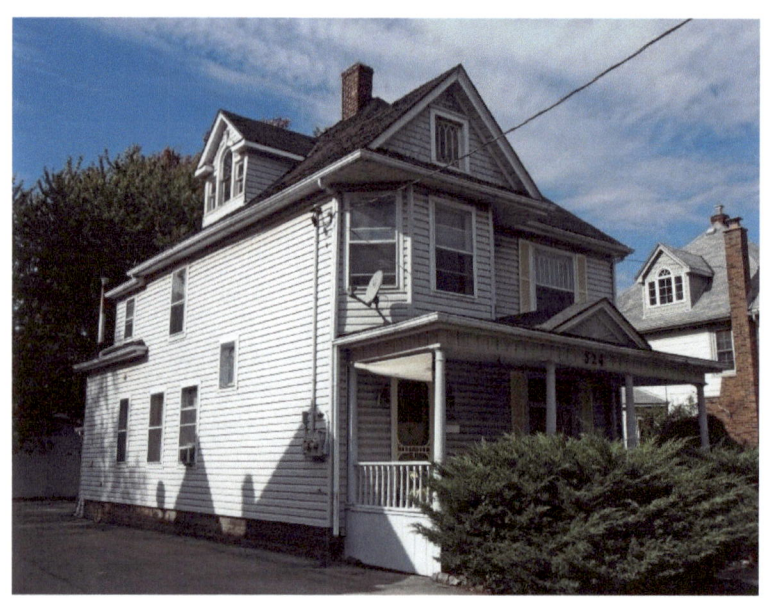

524 King Street – dormers, second floor bay window, pediment

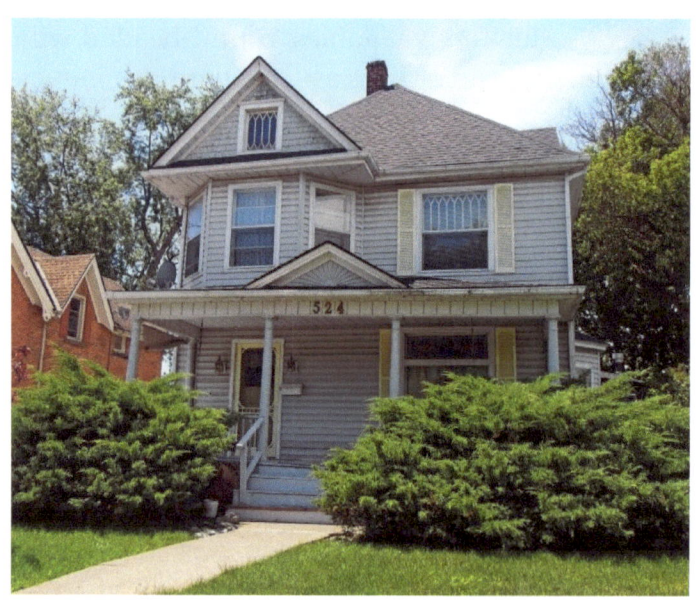

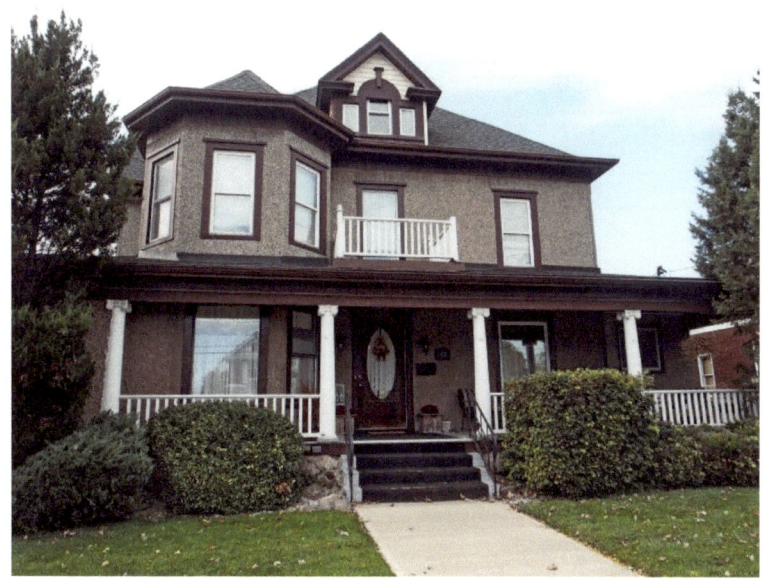

550 King Street – dormer with cornice return on gable, second floor bay window and balcony, composite capitals on the verandah supports

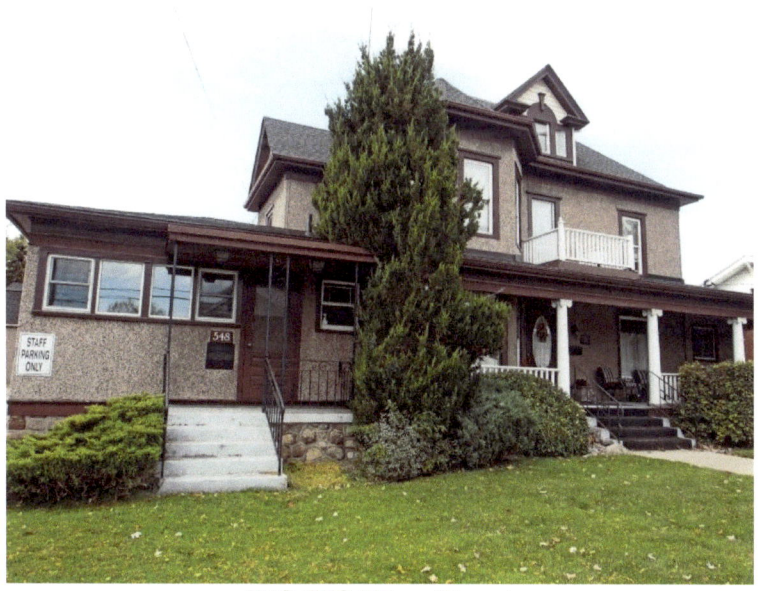

548-550 King Street

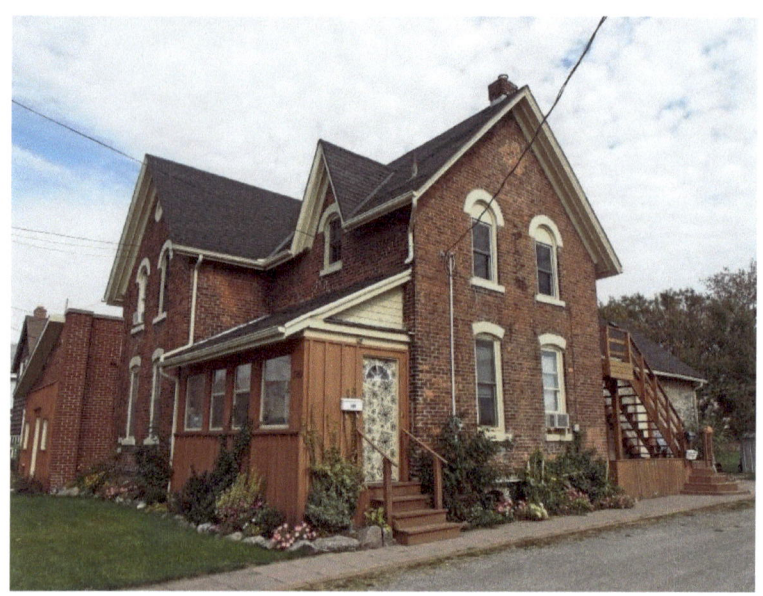

589 King Street – Gothic Revival

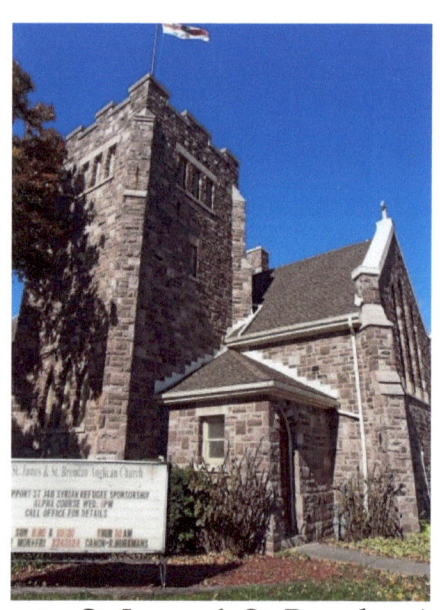

55 Charlotte Street – St. James & St. Brendan Anglican Church – The present Gothic and Tudor Revival building with a solid crenellated tower was opened in 1917.

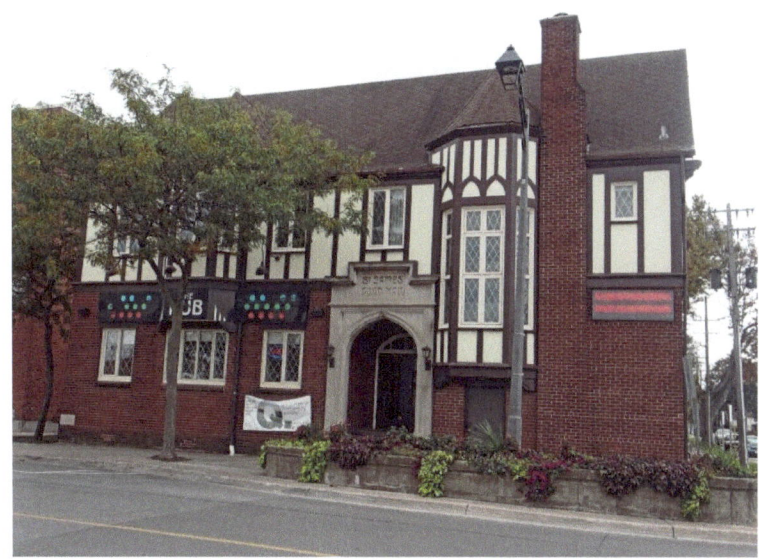

72 Charlotte Street – St. James' Guild Hall – Tudor style, turret

253 Charlotte Street

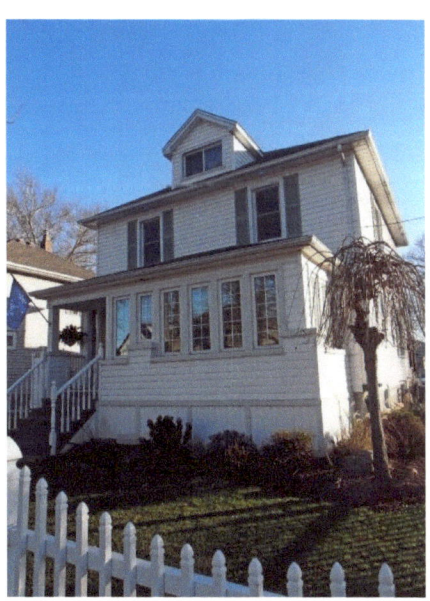

276 Charlotte Street

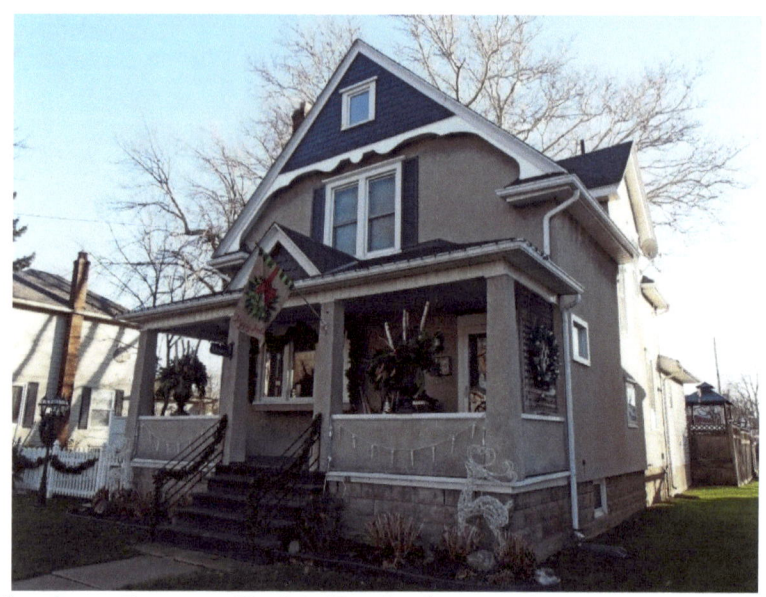

Charlotte Street – Gothic Revival – cornice return on gable with verge board trim, pediment

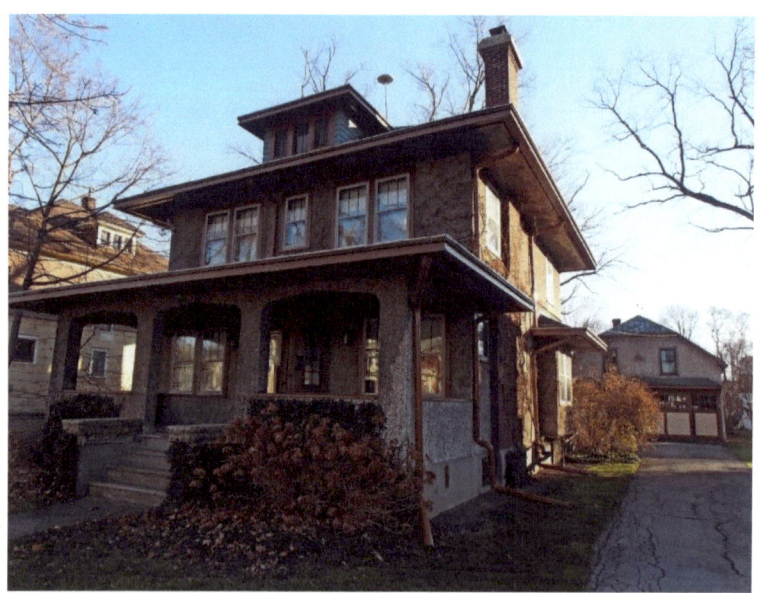

238 Charlotte Street – hipped roof, dormer

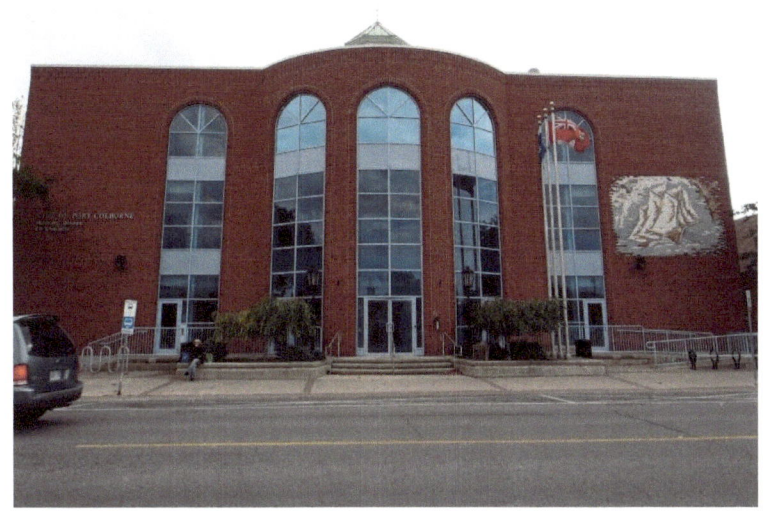

66 Charlotte Street - City Hall – Art Moderne style

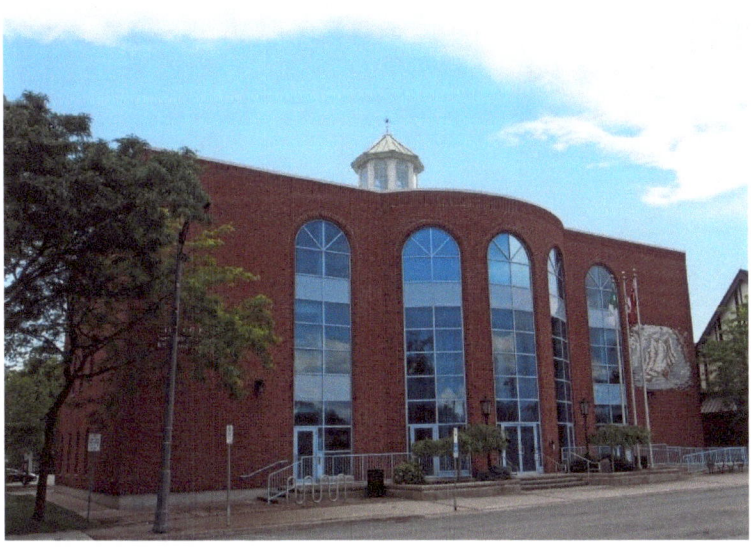

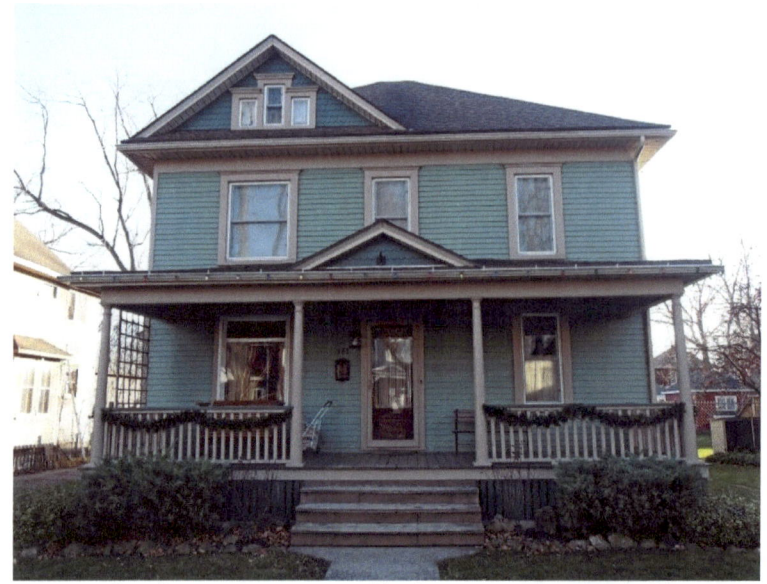

248 Charlotte Street – Palladian window, pediment

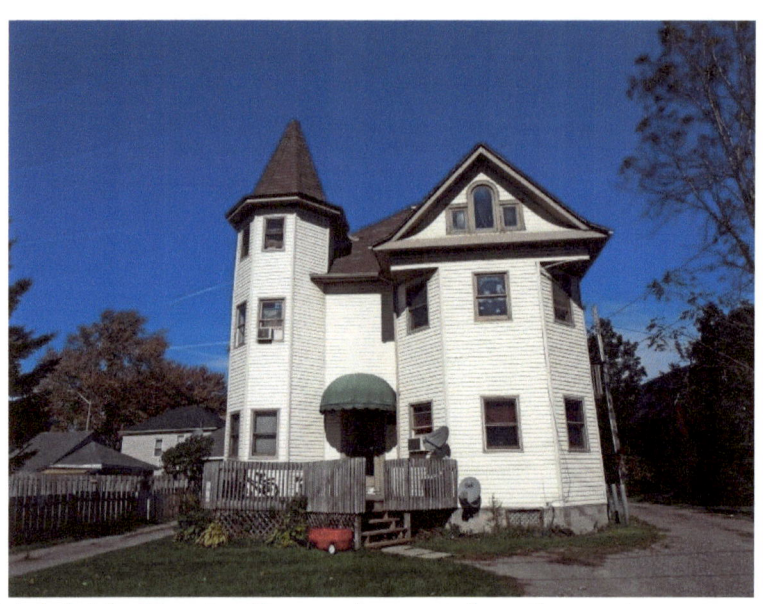

2 Adelaide Street – Queen Anne style – three-storey tower with cone-shaped roof, Palladian window in 2½- storey tower-like bay

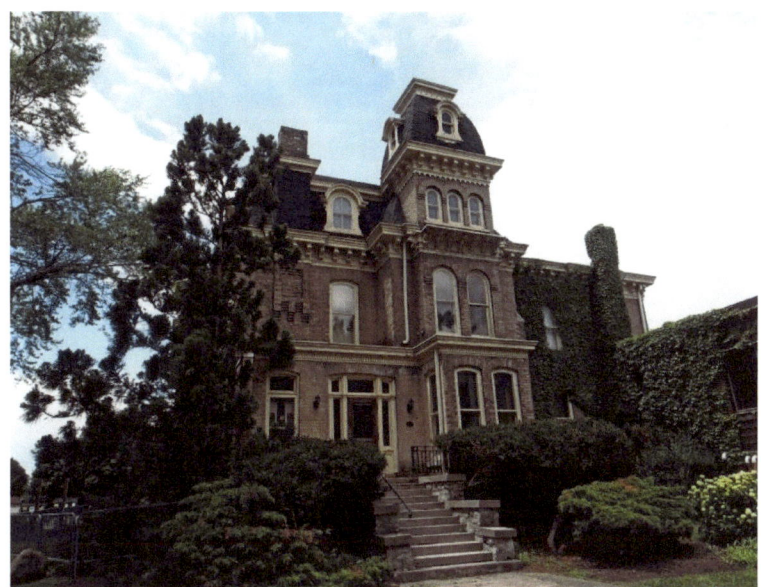

296 Fielden Avenue – This magnificent stone and brick Victorian building was erected circa 1860 for Levi Cornwall. Lewis Carter had it redone in its present Italianate/Second Empire form about 1879 with ornately bracketed eaves, multiple bays, mansard roofs, an impressive three-storey tower with four double-hung "Port Colborne" windows, and round headed or elliptical shaped windows, some paired or tripled.

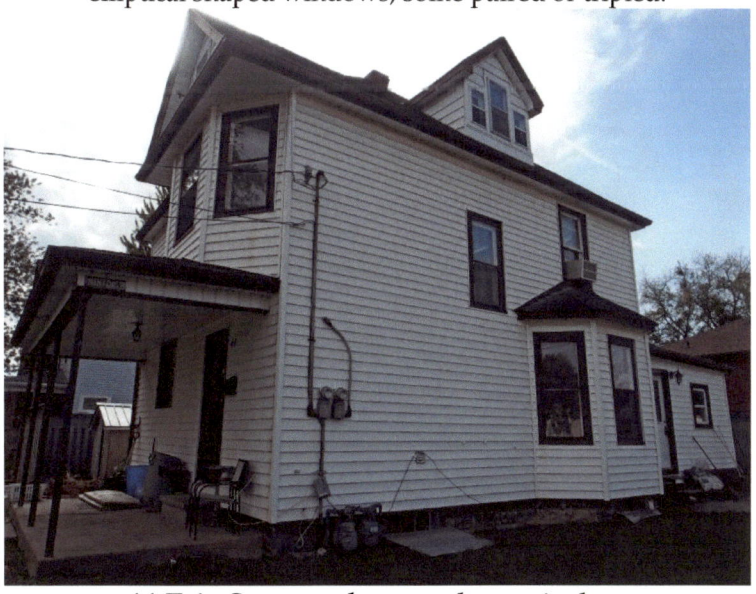

44 Erie Street – dormer, bay window

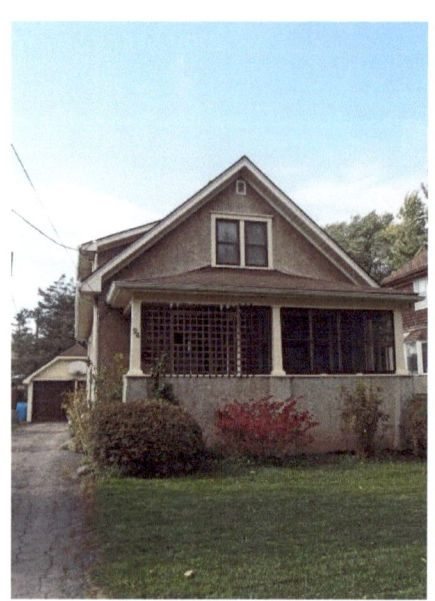
24 Erie Street
Vernacular

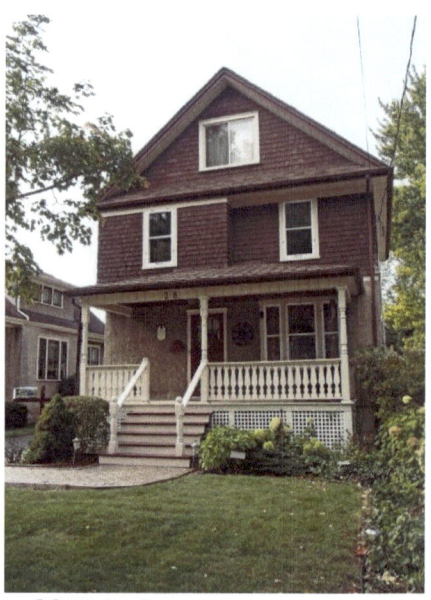
28 Erie Street
Edwardian

57 Erie Street – Ontario Cottage

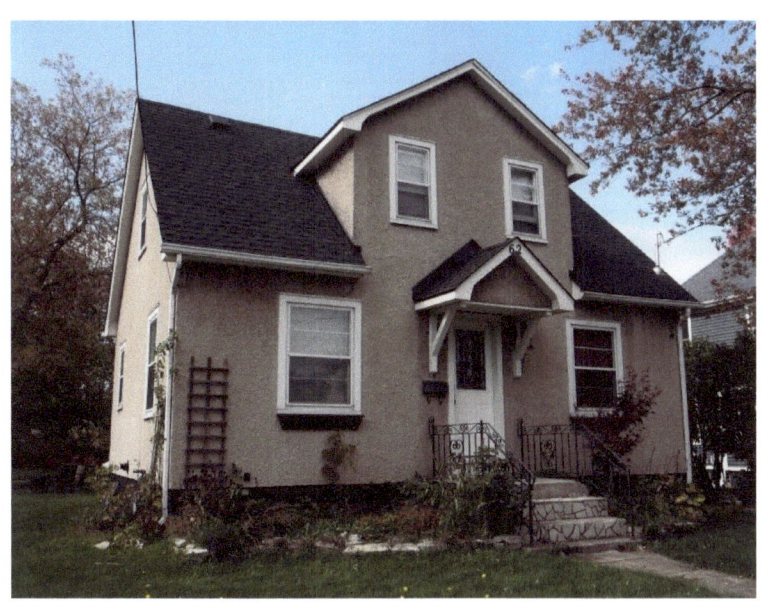

62 Erie Street – vernacular

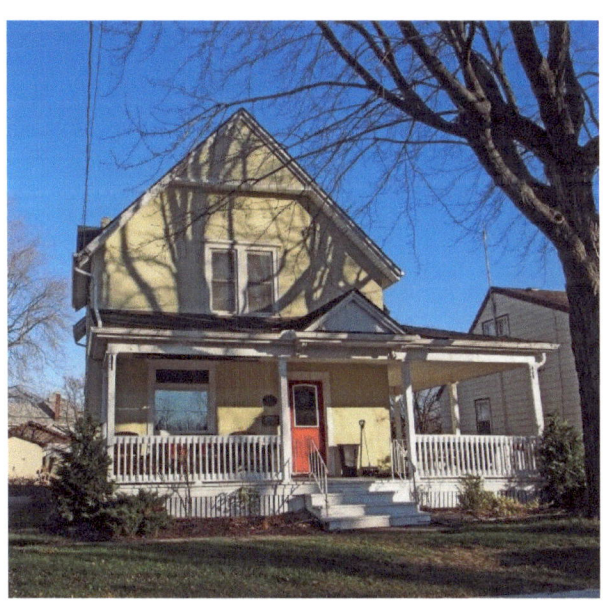

75 Erie Street

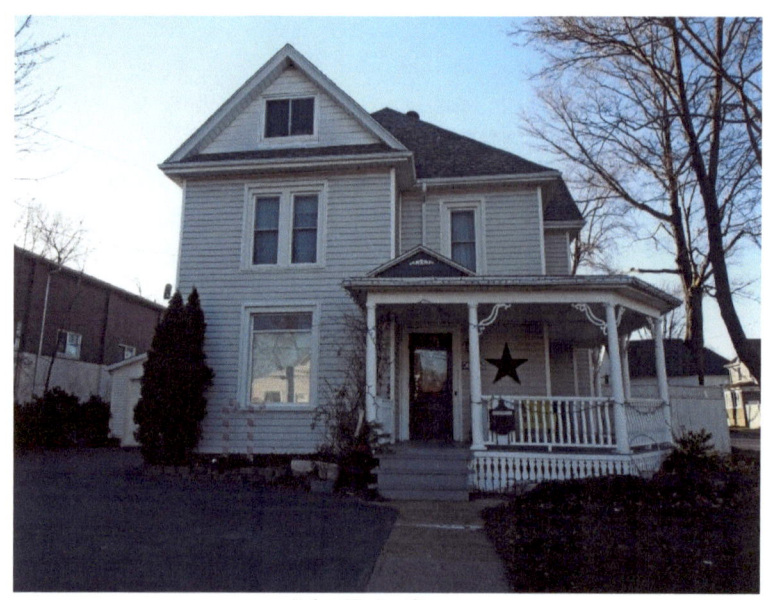

#6_ Erie Street

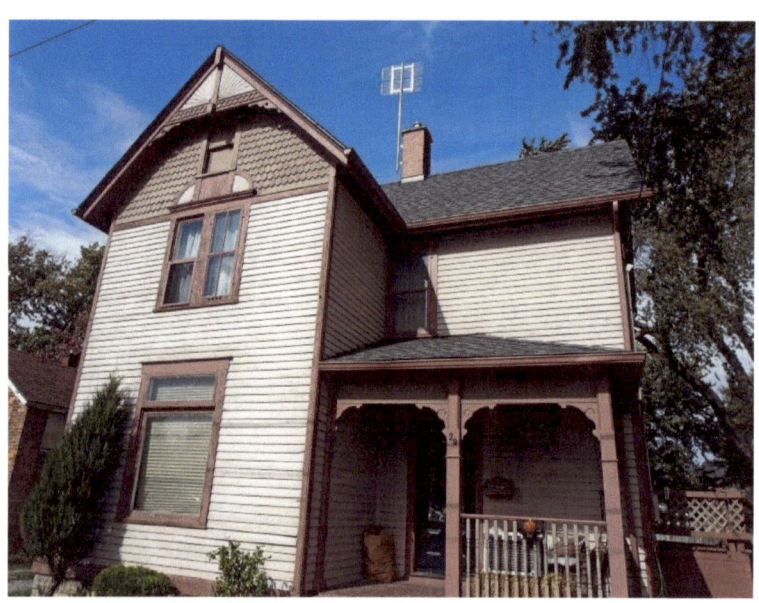

29 Killaly Street West – Gothic

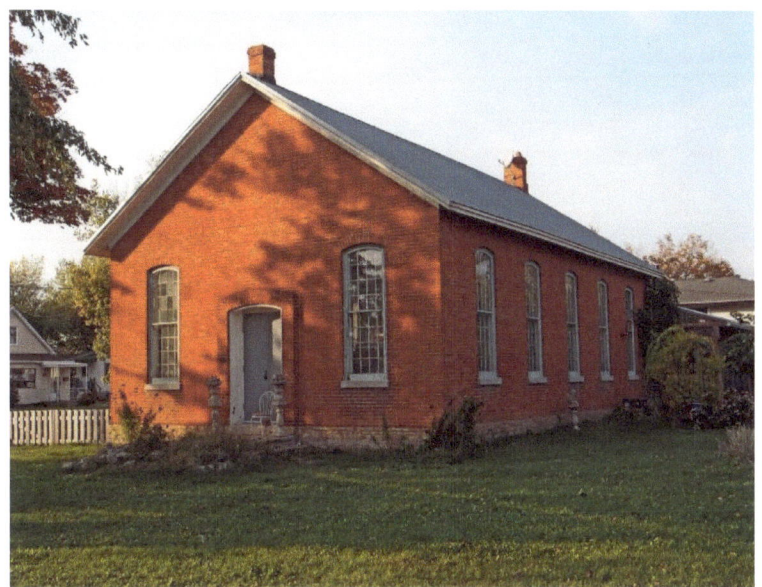

269 Killaly Street West – Old Mennonite Meeting House – 1872 – brick building with traces of Italianate style in the original multi-paned windows with segmentally arched tops

404 Catharine Street

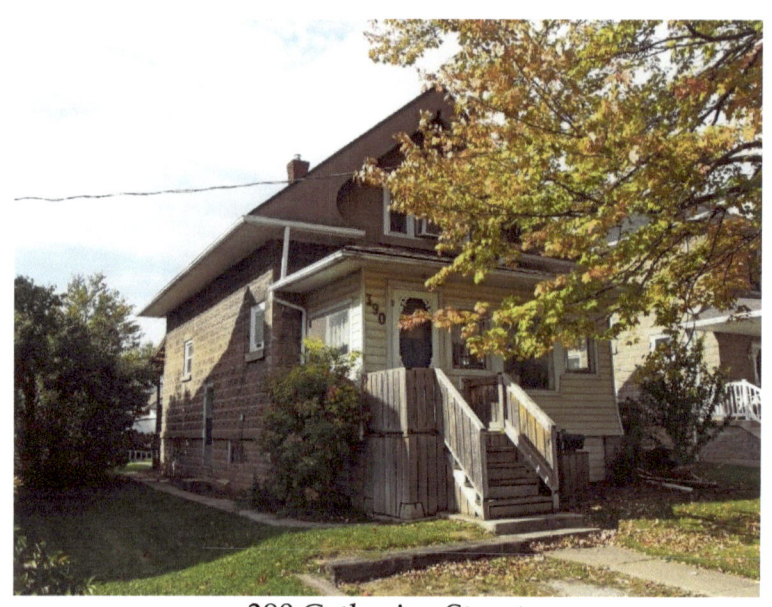

390 Catharine Street

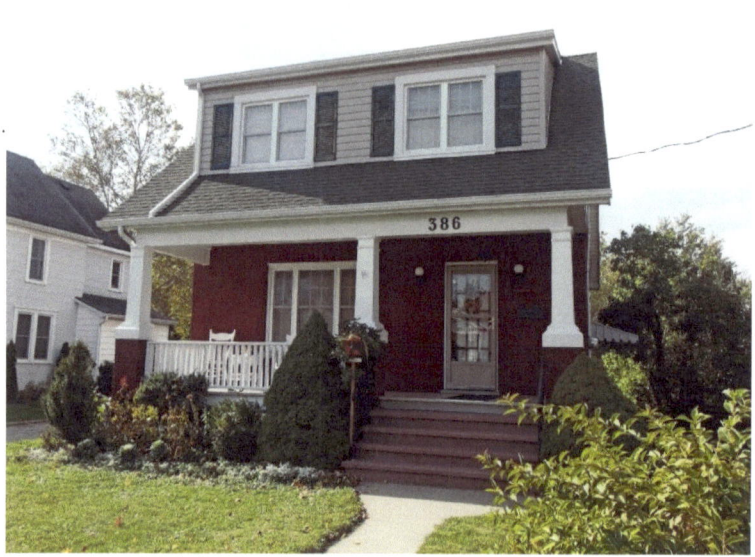

386 Catharine Street – shed dormer

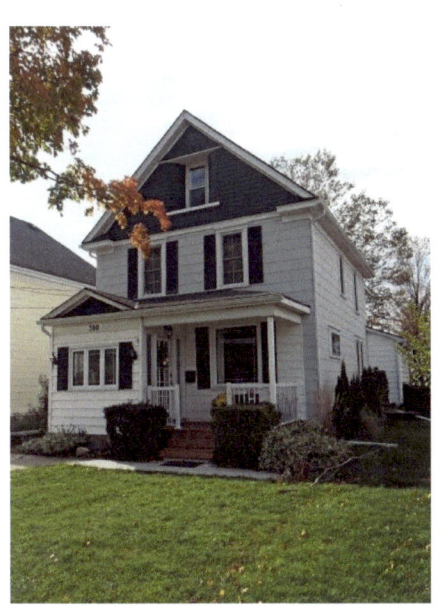

380 Catharine Street
Edwardian
Pediment

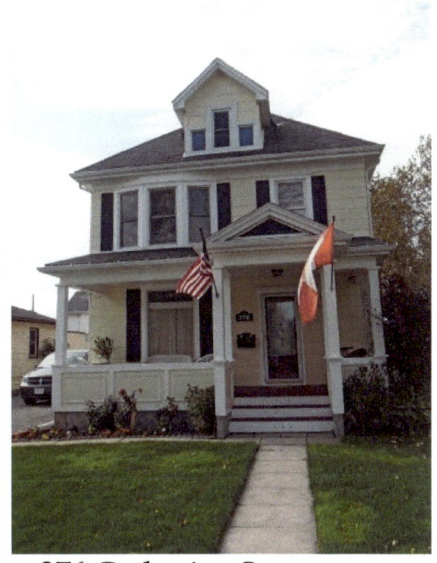

376 Catharine Street
hipped roof, dormer,
pediment

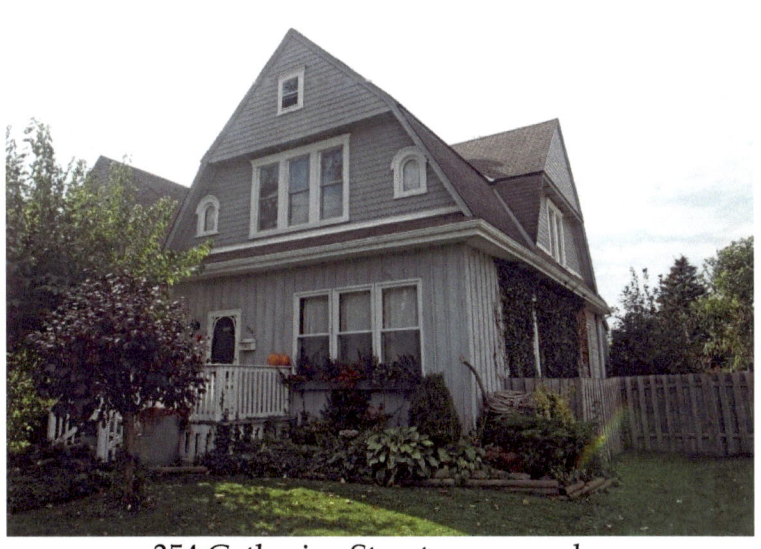

354 Catharine Street – vernacular

346 Catharine Street – The former St. James' Anglican Church Rectory (until 1957) was built in two stages with the eastern portion built for Lewis Carter c. 1875 and the western part was added when the house was purchased as a rectory in 1897. Note the two-storey bay window in the west wing, and round-headed windows capped with brick voussoirs which indicate the Italianate style.

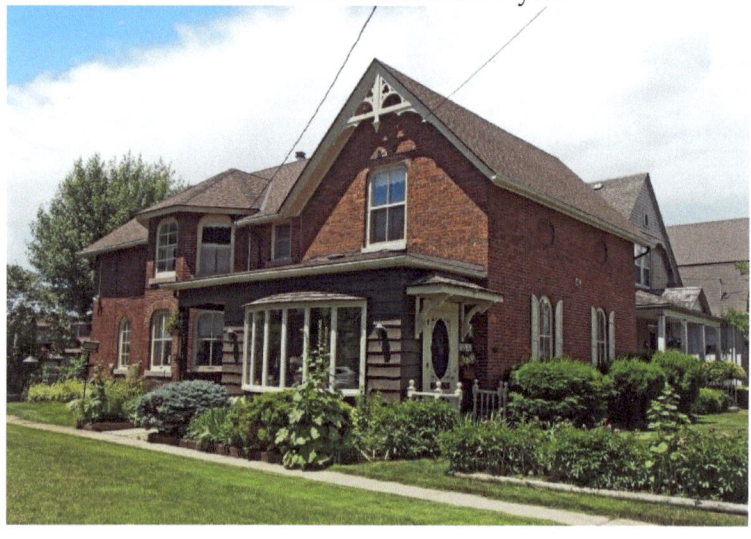

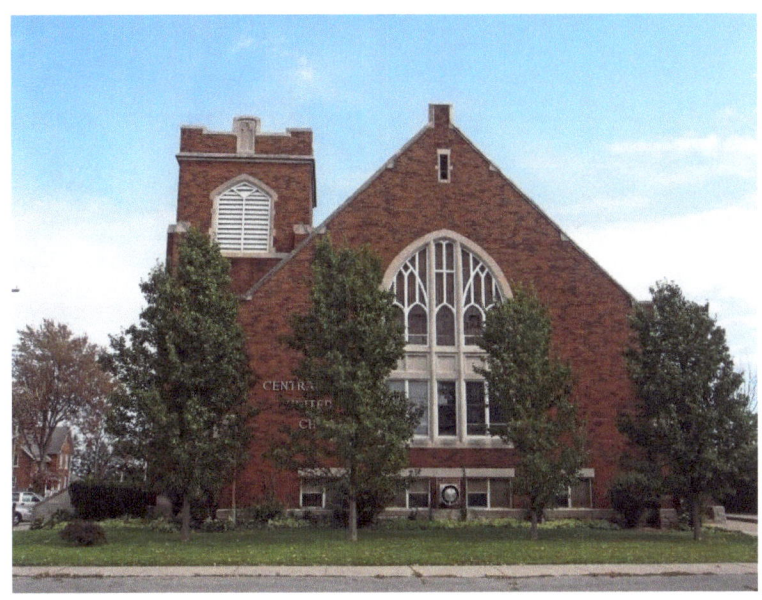

30 Delhi Street at the corner of Catharine Street – Central United Church – tower with battlement parapet, window muntins, buttresses, dichromatic voussoirs

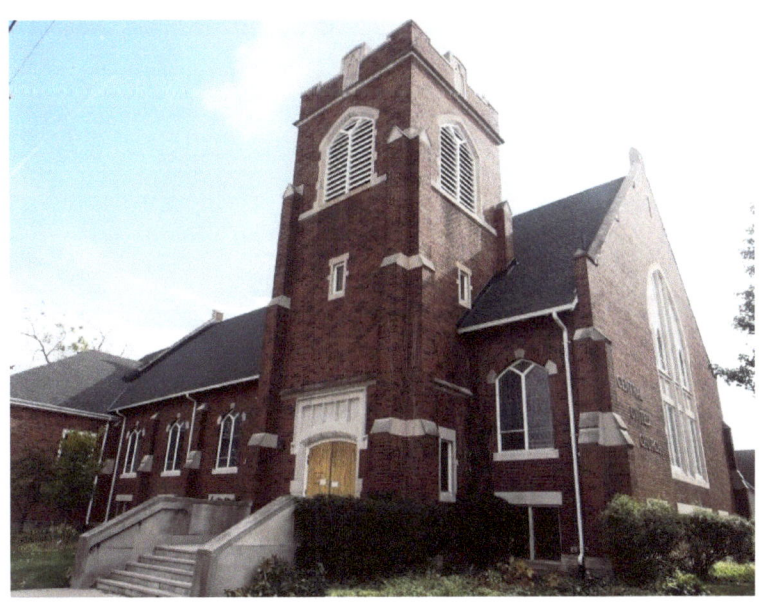

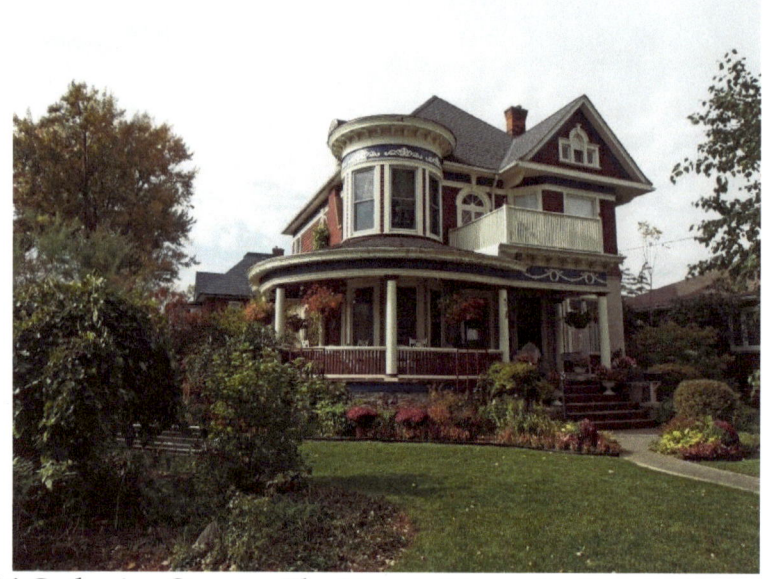

326 Catharine Street – The Harvie House built in 1900, it is a typical Queen Anne Revival style home and has a wraparound verandah with offset circular tower, two types of siding and a pyramidal roof. The house takes its name from the Harvie family who owned it from 1911 to 1951.

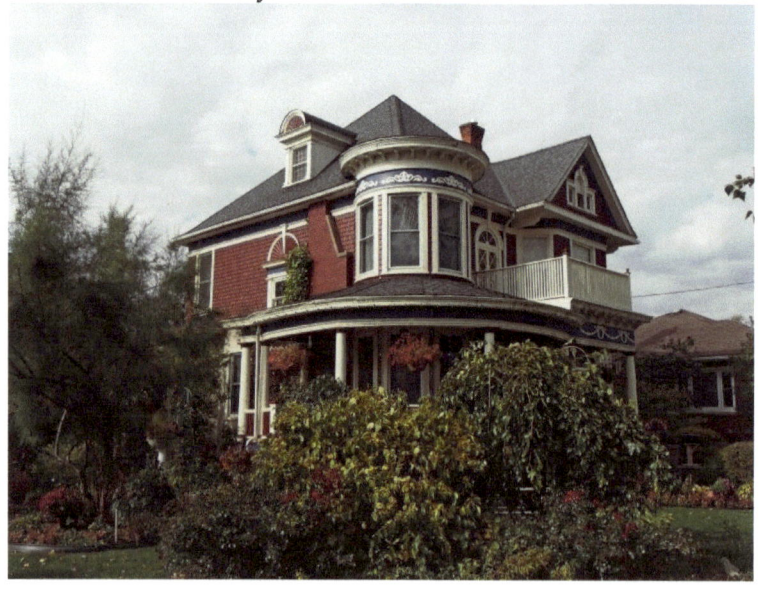

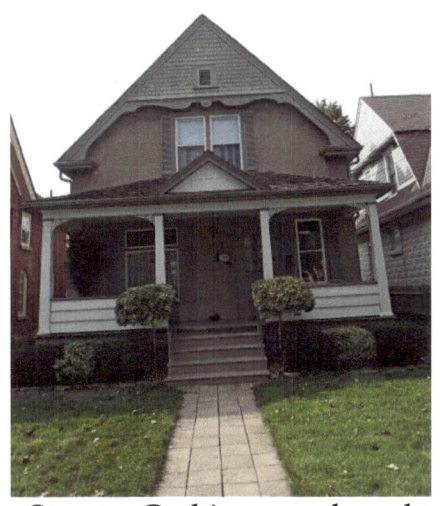

350 Catharine Street – Gothic, verge board trim on gable, pediment

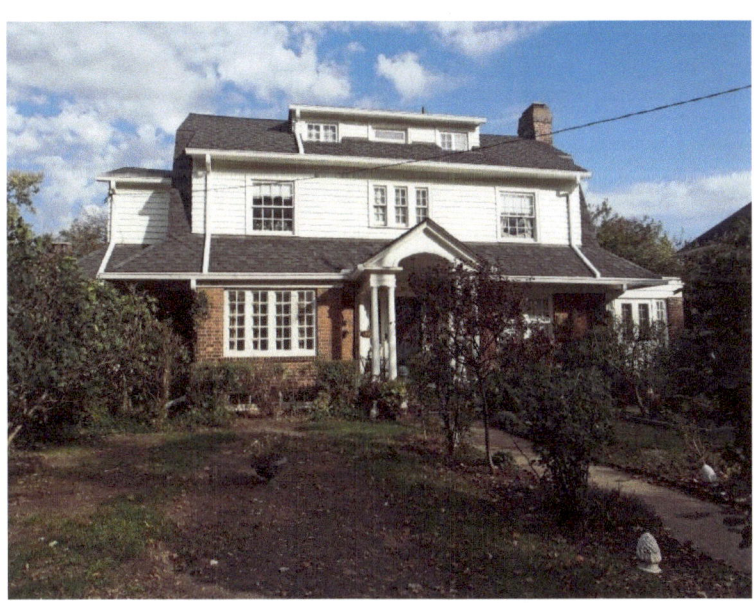

23 Catharine Street – shed dormer

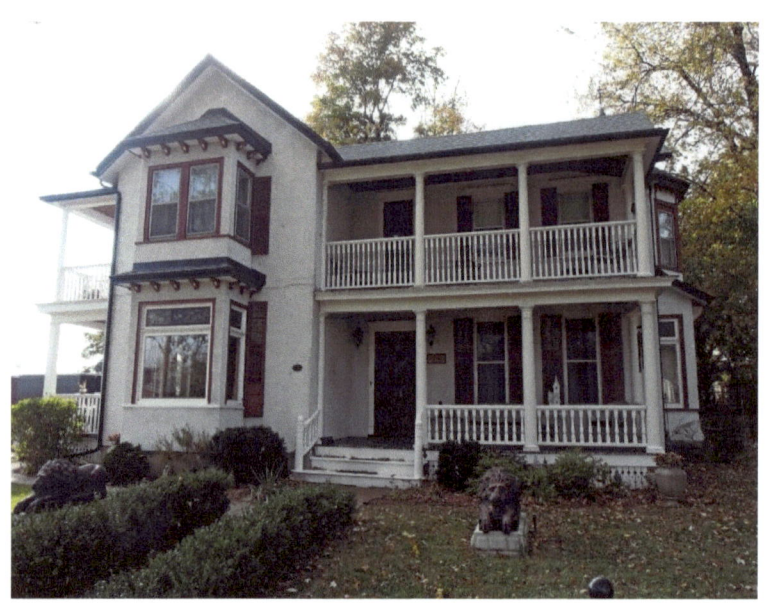

14 Catharine Street – Wildwood – c. 1875 – This house displays an eclectic mix of late Victorian styles with a mix of bays, an oriel window and turret on its north side in contrast to the restrained Greek Revival style of the east and south facades. It began as a small two-storey brick house built by William Arnott on the lake shore in 1876. In 1886 it was purchased as a summer and retirement home by Carolina residents, Joseph and Alice Dickenson, who enlarged it to its current form. The cast metal lions were imported from the Carolinas by the Dickensons. The New England influence is evident in the architectural styles.

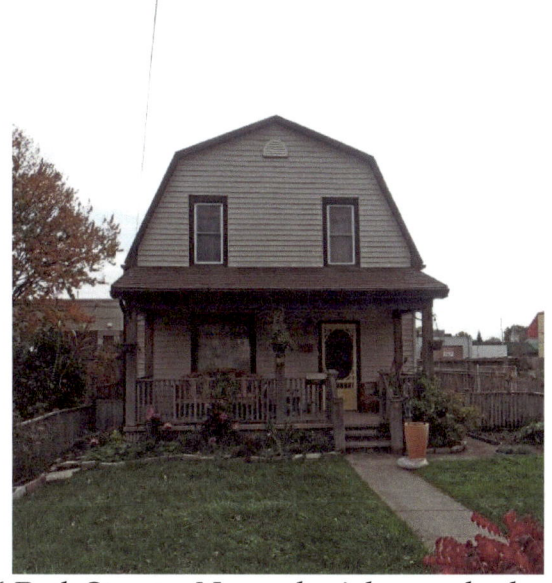

16 Park Street – Neo-colonial – gambrel roof

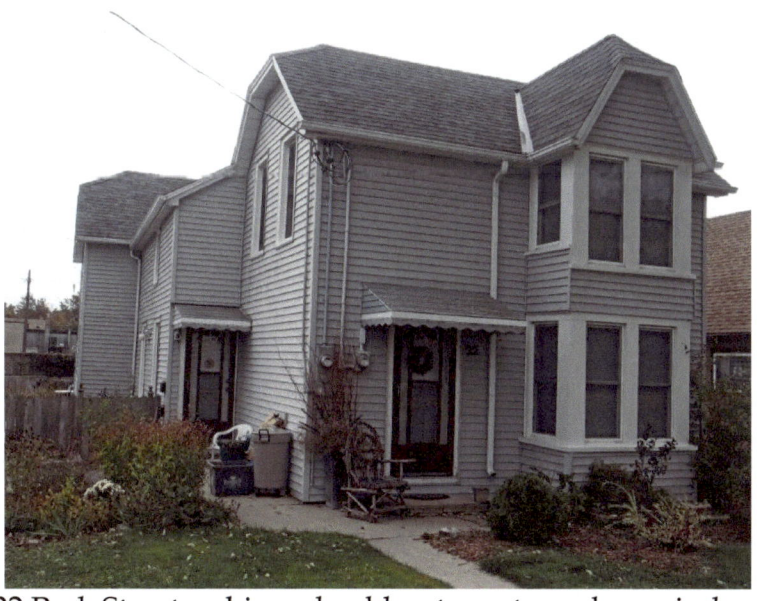

22 Park Street – chipped gables, two-storey bay window

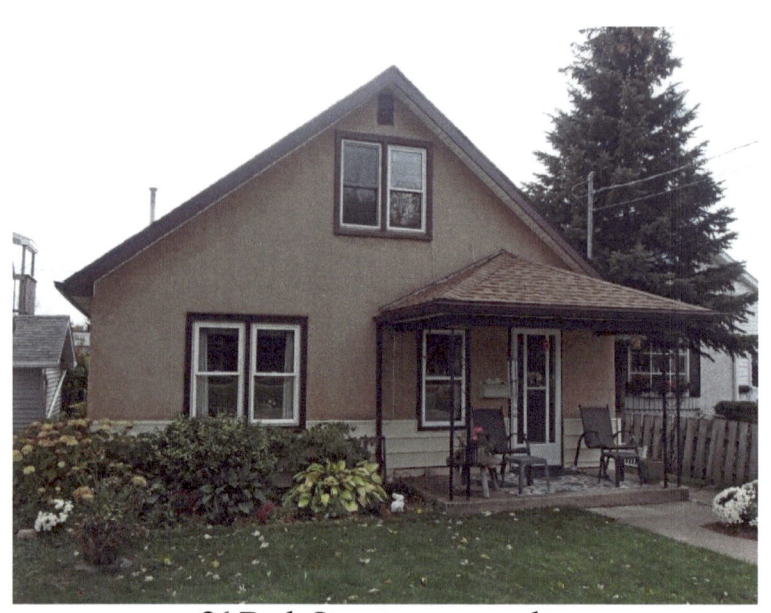

26 Park Street – vernacular

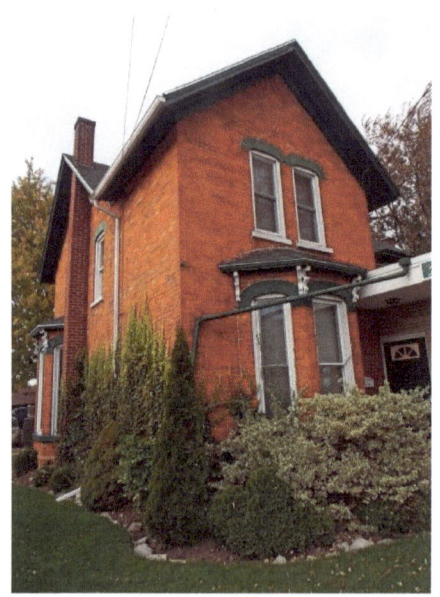

262 Park Street – Gothic, bay window

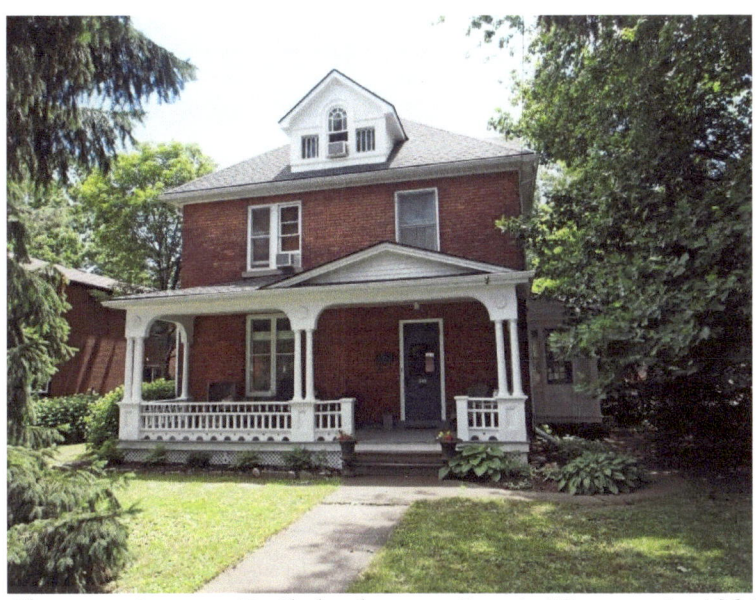

232 Clarence Street – Built by lawyer Louis Kinnear in 1904, it was the home of his daughter Judge Helen Kinnear from 1904-1943, the year she became the first federally appointed woman judge in Canada and the Commonwealth. Helen Kinnear was also the first woman in the Commonwealth to be granted in 1934, "King's Council," a distinction given to noteworthy lawyers. She was also the first woman lawyer to appear before the Supreme Court of Canada. The house exhibits a combination of Edwardian and Victorian architectural styles.

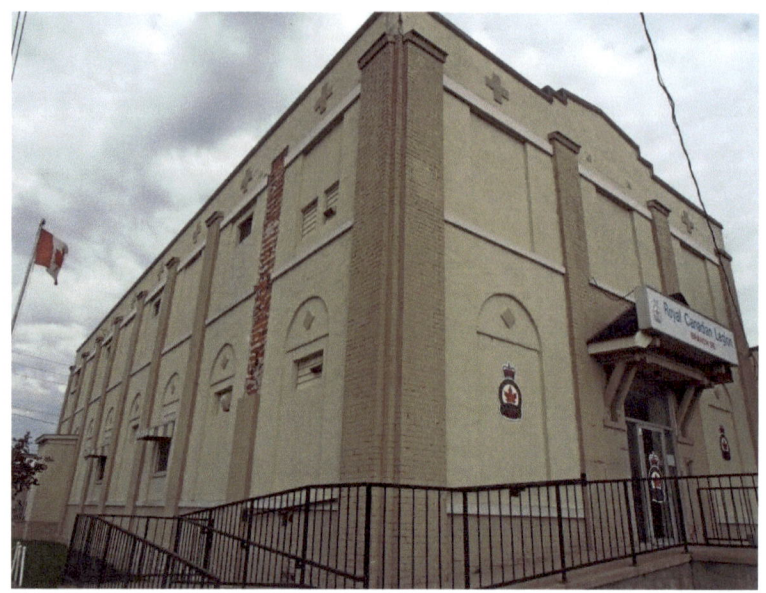

67 Clarence Street – Royal Canadian Legion – pilasters

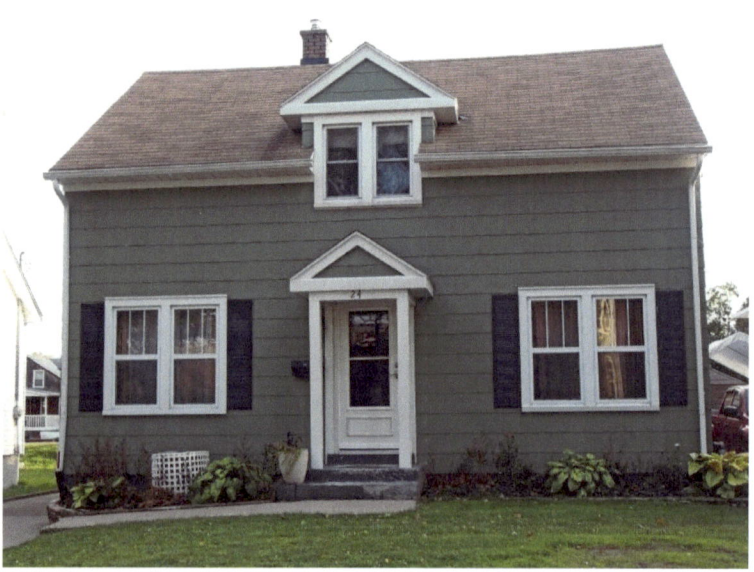

24 Carter Street – Ontario Cottage, dormer, pediment

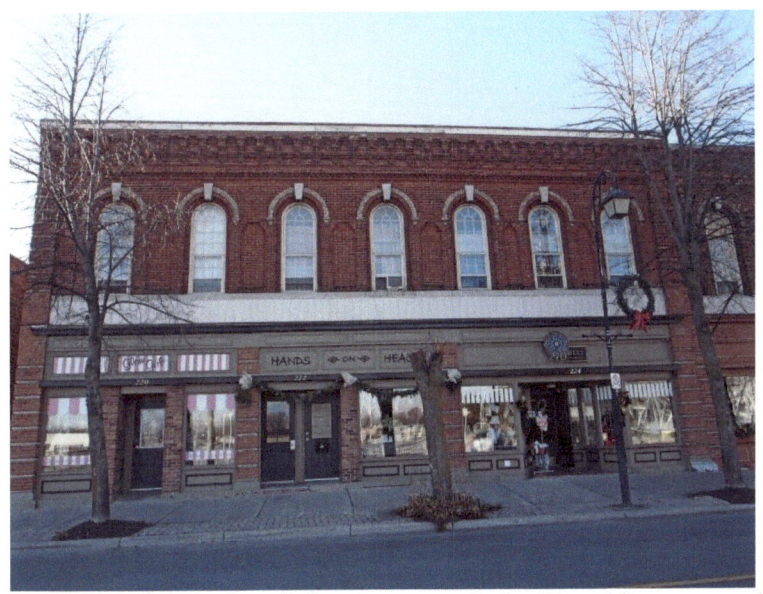

220-224 West Street – beveled and saw tooth dentil molding, voussoirs with keystones in contrasting brick ("Glam Girl", "Hands on Health", "270º West Ladies Casual Wear")

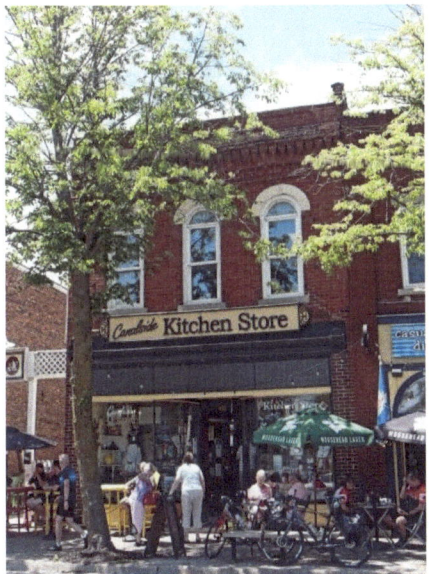 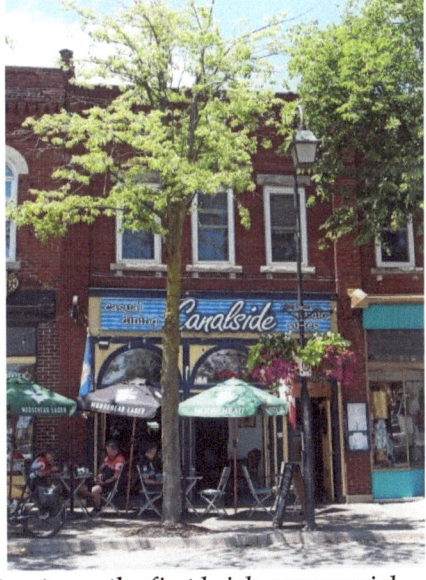

230 & 232 West Street – 230 West Street was the first brick commercial building in town. It was built in 1850 for Lewis Carter who operated it as a general store. It is in the Italianate style with a flat roof, rounded windows and a dominant cornice.

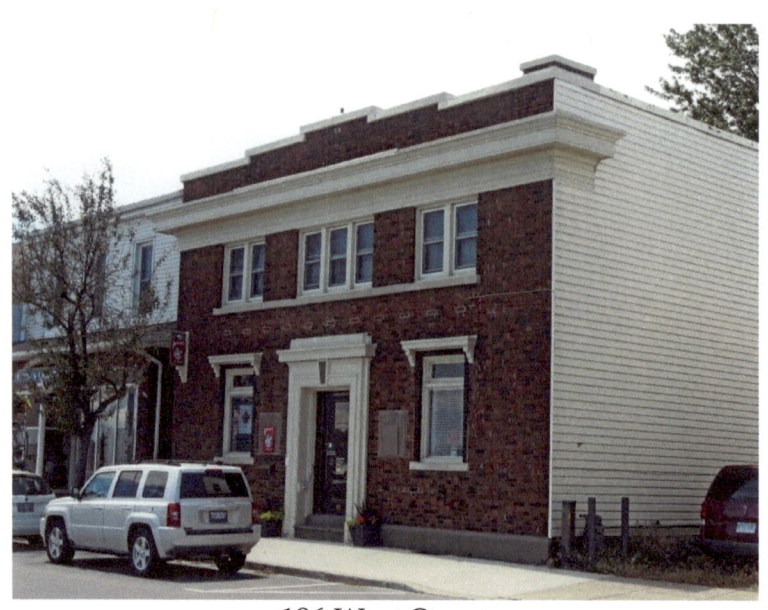

196 West Street

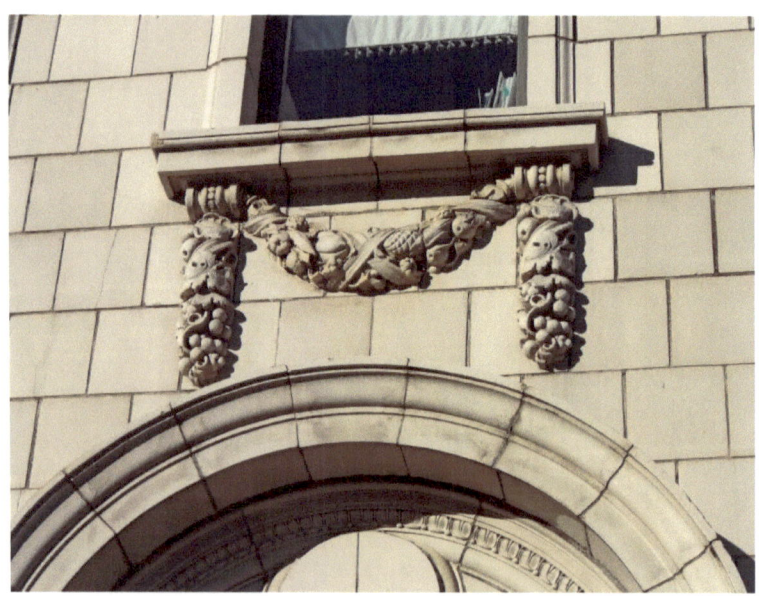

212 West Street – There are festoons of flowers, nuts and ribbons below the window slipsills and along the sides of the windows.

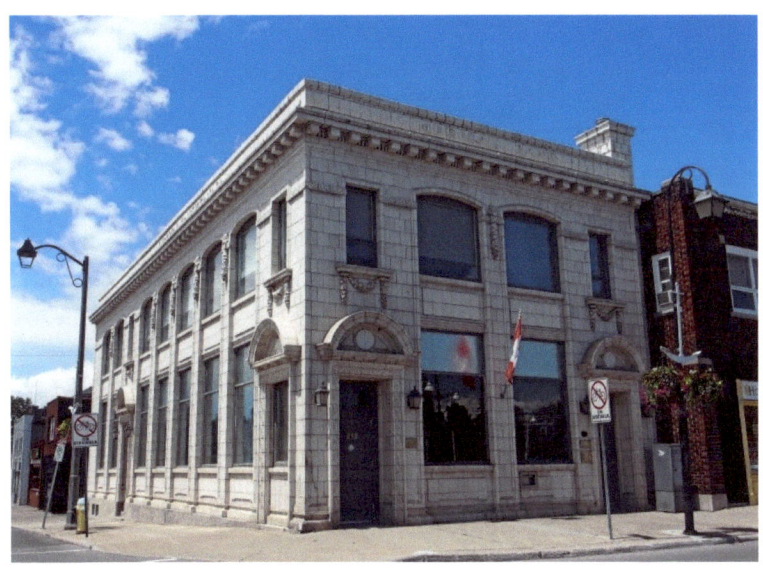

212-214 West Street – Constructed in 1911, the Imperial Bank of Commerce has a terra cotta exterior and is in the Beaux Arts style. There is a dominant cornice and arched windows.

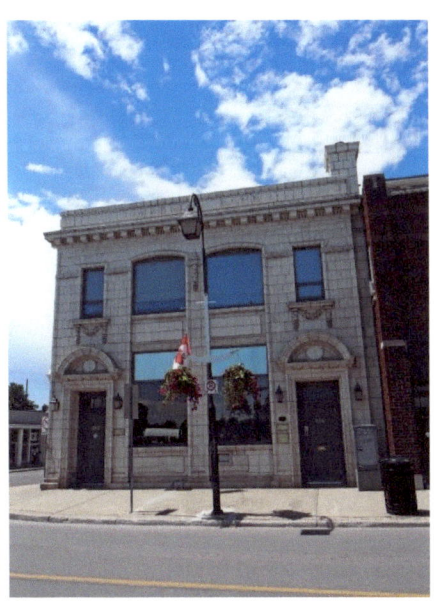

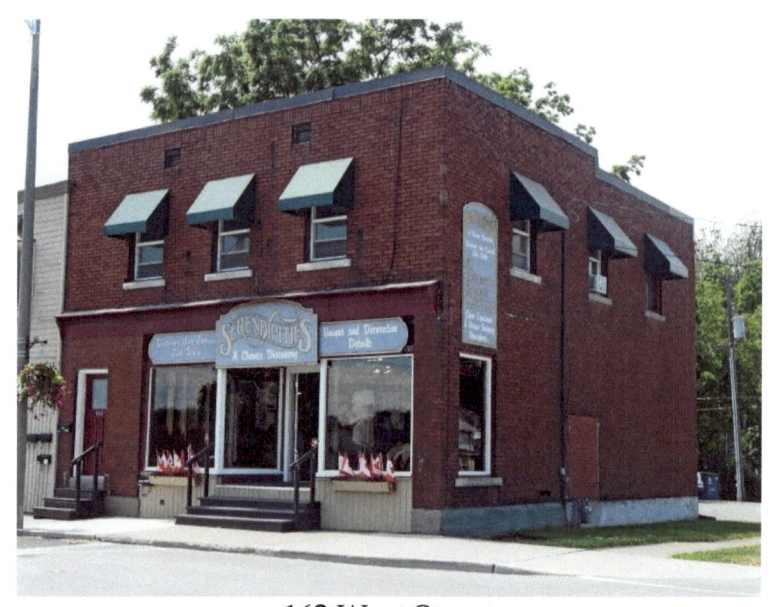

162 West Street

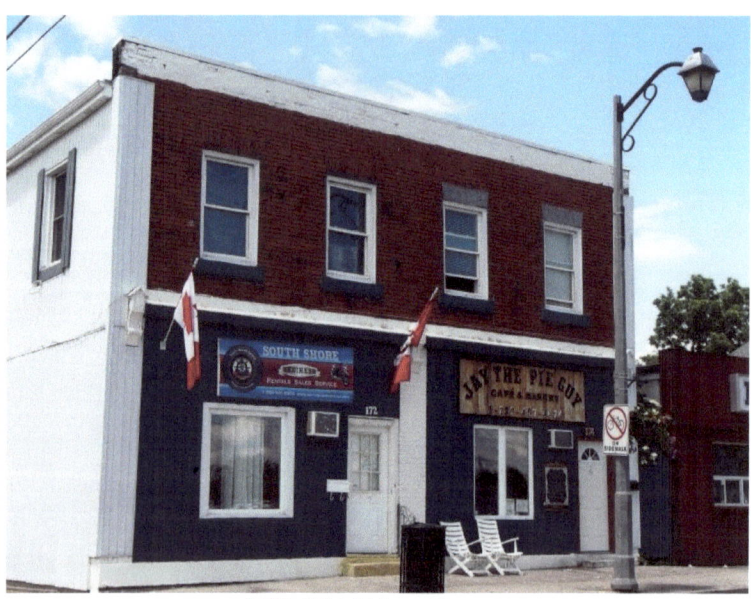

172-174 West Street

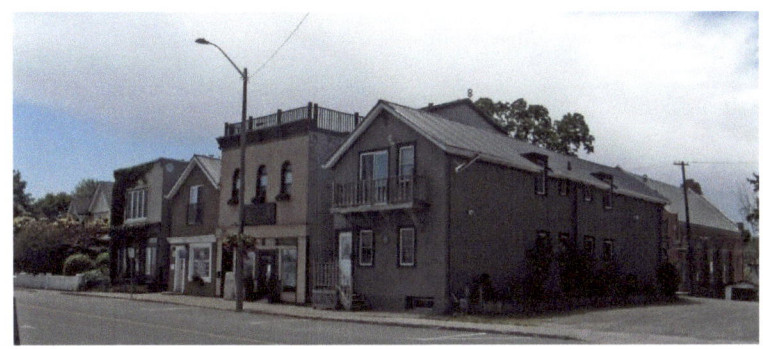

West Street

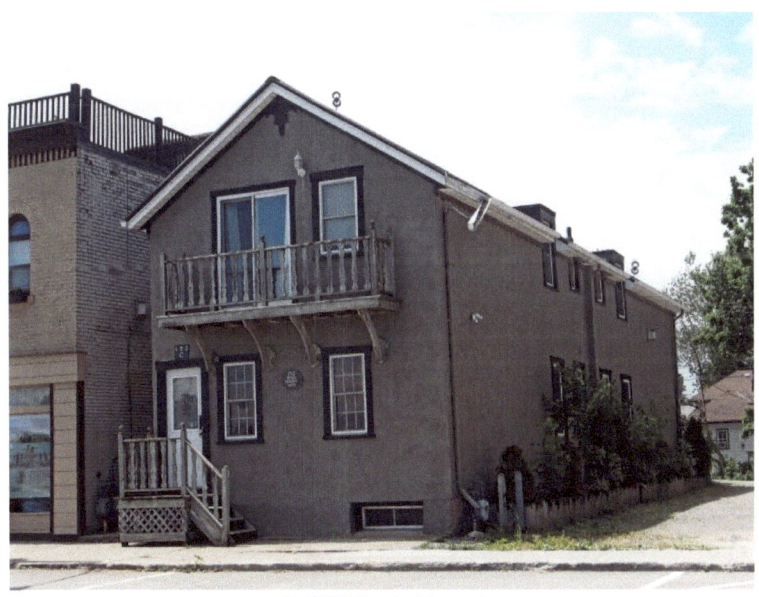

152 West Street

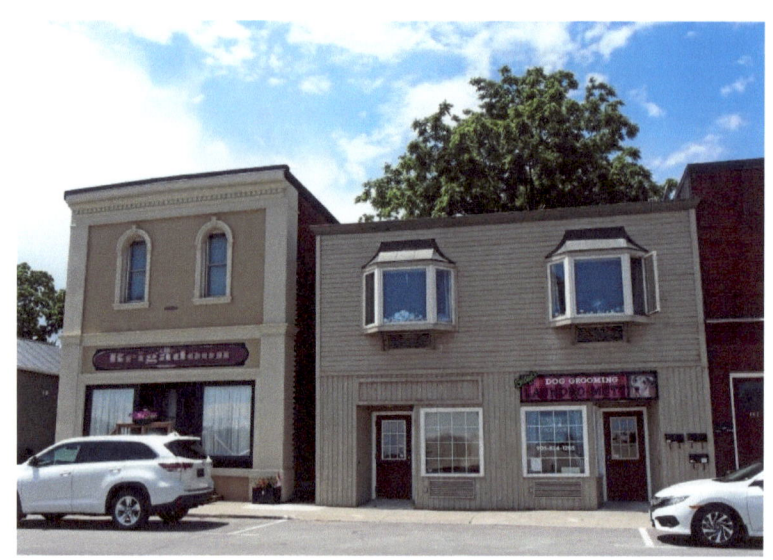

158-160 West Street

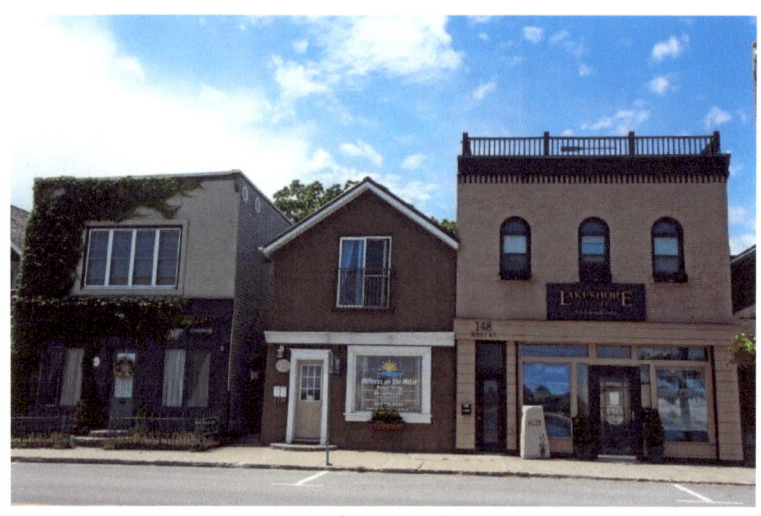

144-148 West Street

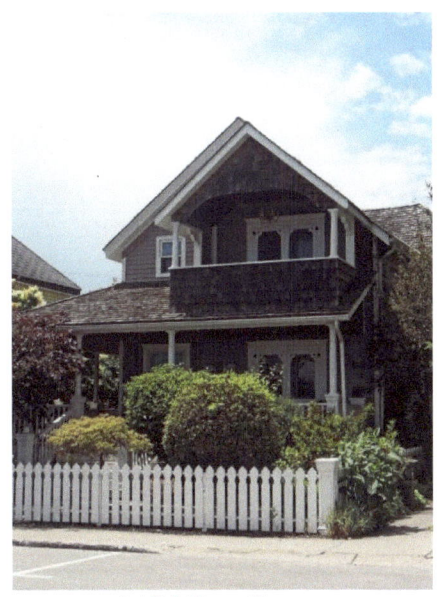

142 West Street

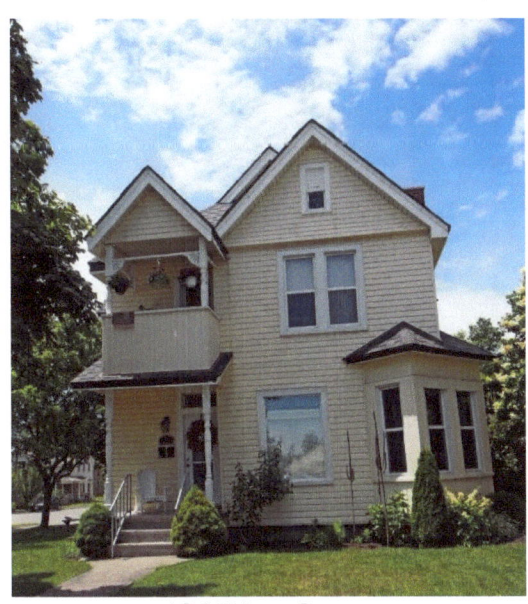

136 West Street

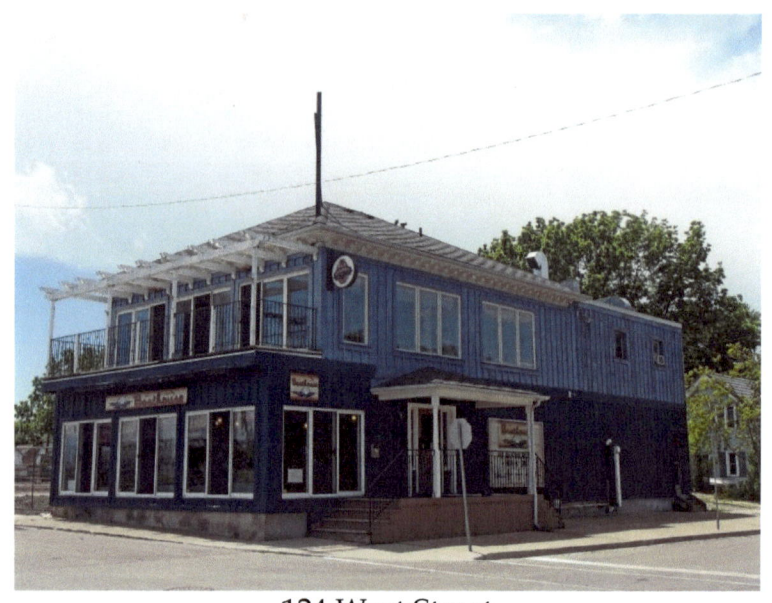

124 West Street

100 West Street

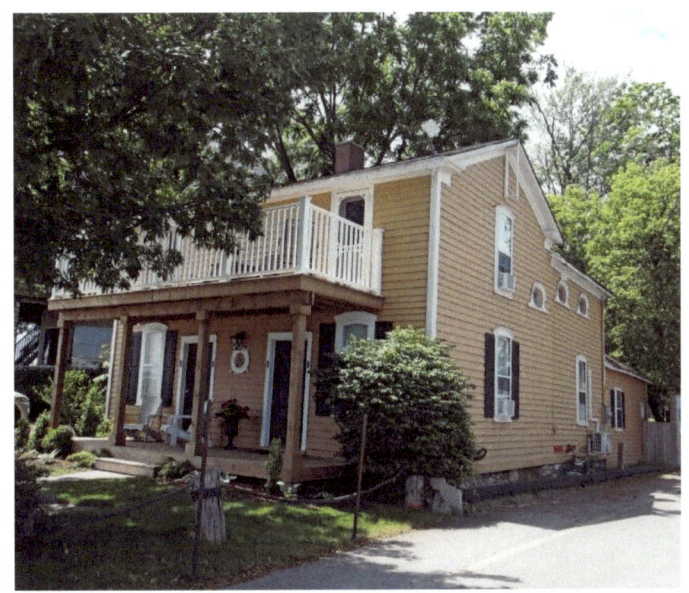

62 West Street was known originally as the Lakeview Hotel and was built about 1840. The almost oval "Port Colborne windows" are straight sided with two rounded ends (thought to be the mark of a local craftsman).

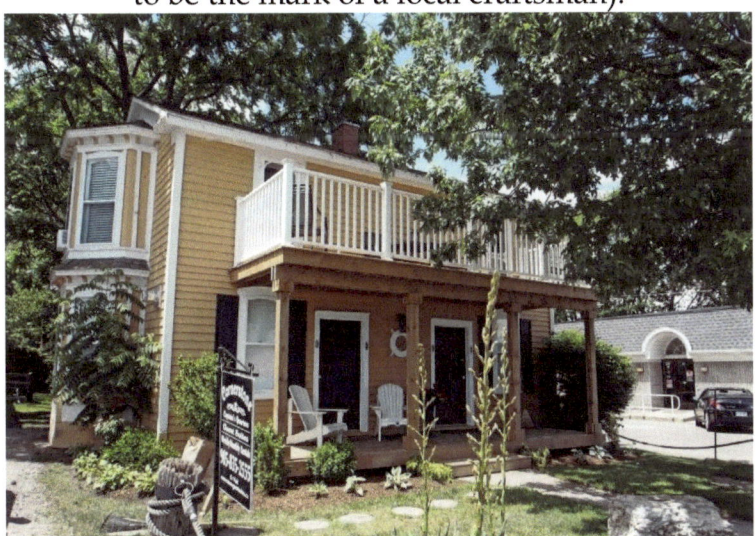

Two-storey bay window

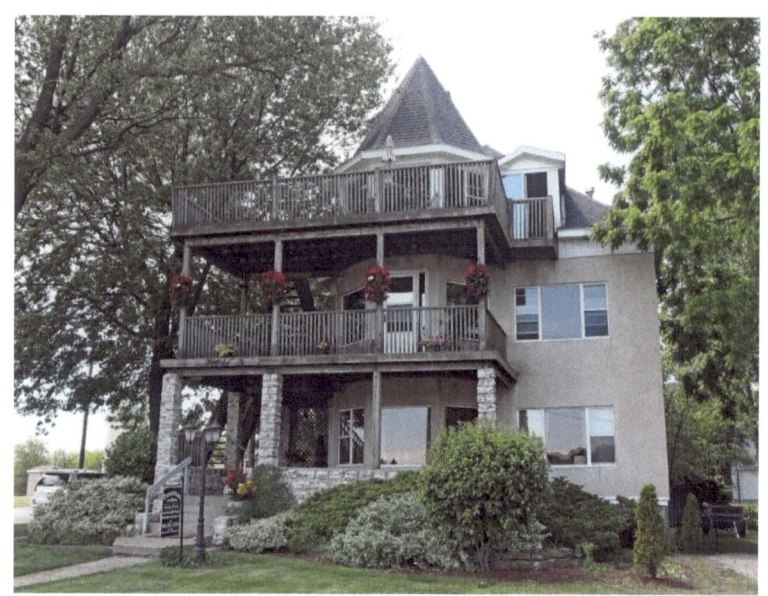

56 West Street – turret with capped roof, second and third storey balconies

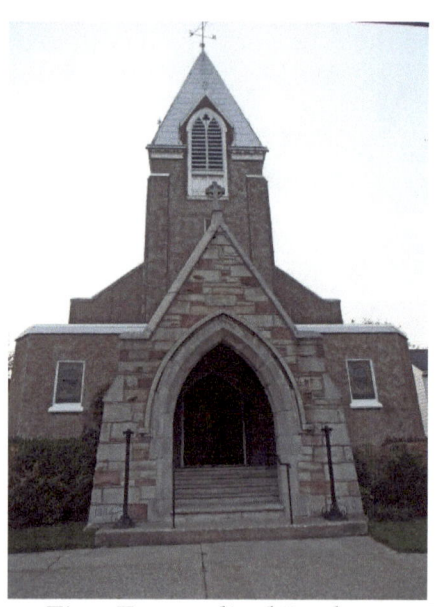

688 Elm Street – First Evangelical Lutheran Church – 1884

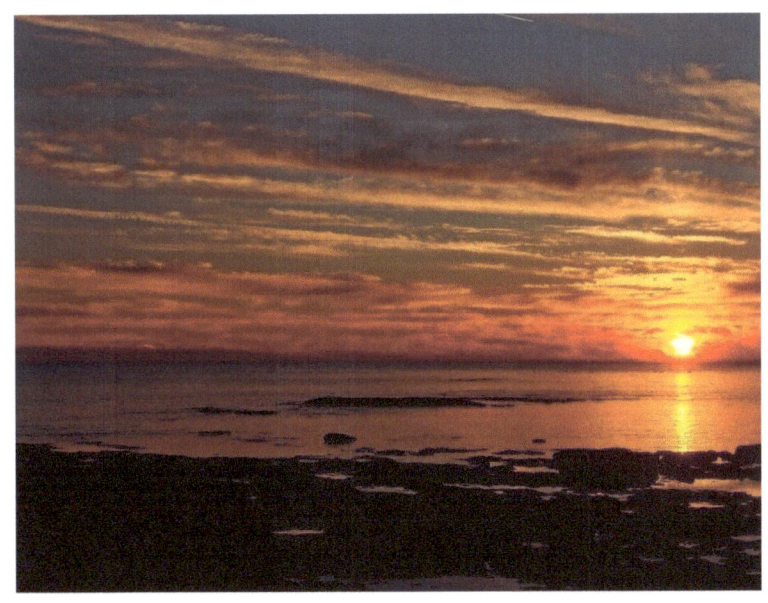

Sunset over the water

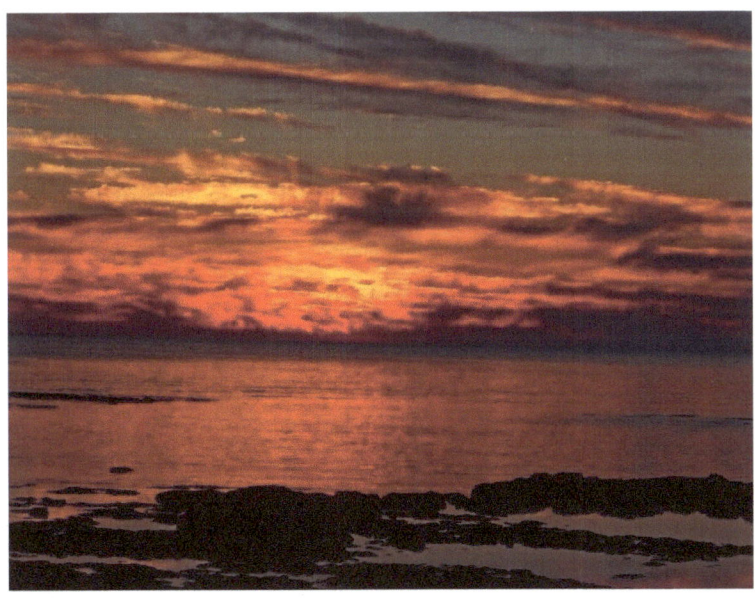

Architectural Terms

Battlement: A design for a parapet that has alternating solid parts and openings, originally used for defense, but later used as a decorative motif. Example: 30 Delhi Street, Page 45	
Bay Window: A window that projects out from a wall, in a semicircular, rectangular, or polygonal design. Used frequently in Gothic and Victorian designs. Example: 44 Erie Street, Page 37	
Brackets: a decorative or weight-bearing structural element which forms a right angle with one side against a wall and the other under a projecting surface such as an eave or roof. Example: 322 King Street, Page 25	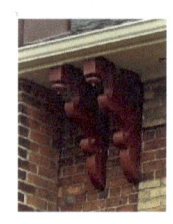
Buttress: a masonry structure built against or projecting from a wall which serves to support or reinforce the wall. In Canadian architecture, they are sometimes used for decoration. Example: 30 Delhi Street, Page 45	

Capital: The uppermost finish or decoration on a column. A Composite is a mixture of two or sometimes, three, of the major styles (Ionic - a capital composed of volutes which are carved whirls or twists that take the form of a scroll; Doric - a simple capital with a simple entablature; Corinthian - a rounded capital decorated with acanthus leaves and a square abacus). Example: 550 King Street, Page 31	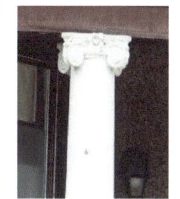
Cornice Return: decorative element on the end of a gable. Example: 550 King Street, Page 31	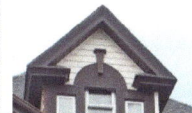
Dentil Molding: an even series of rectangles used as ornamental decoration in cornices. Example: 220-224 West Street, Page 53	
Dichromatic brickwork: the use of two colours of brick, tile or slate to decorate a façade. Example: 322 King Street, Page 25	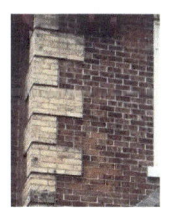
Dormer: (French for "sleep") a gable end window that pierces through the plane of a sloping roof surface to create usable space in the top floor or attic of a building by adding headroom. Example: 376 Catharine Street, Page 43	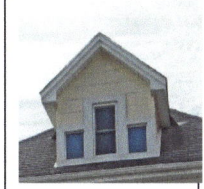

Frontispiece: a portion of the façade of a building, usually a centred doorway that is slightly raised from the rest of the building, usually has extensive ornamentation. Frontispieces are usually Classical in design with white columned porches. Example: 322 King Street, Page 25	
Gable: the triangular portion of a wall between the edges of a sloping roof. Example: 518 King Street, Page 29	
Gambrel Roof: a symmetrical two-sided roof with two slopes on each side; the upper slope is positioned at a shallow angle, while the lower slope is steep. It is similar to a mansard roof, but a gambrel has vertical gable ends instead of being hipped at the four corners of the building. Example: 16 Park Street, Page 49	
Hipped Roof: a roof where all sides slope downwards to the walls with no gables. Example: 376 Catharine Street, Page 43	
Keystones and Voussoirs: a voussoir is a wedge-shaped element used in building an arch. A keystone is the central stone that locks all the stones into position, allowing the arch to bear weight. A keystone is often enlarged and embellished. Example: 220-224 West Street, Page 53	

Lancet Window: a tall, narrow window with a pointed arch at its top. Example: 123 King Street, Page 11	
Muntin: When a window unit has more than one pane, the material that separates the panes is called the muntin. The larger, more decorative separations are called mullions. In stained glass windows, each piece of colored glass is held in place by a muntin. These were traditionally made of iron. Example: 30 Delhi Street, Page 45	
Palladian Window: a large window that is divided into three sections with the centre section larger than the two side sections and usually arched. Example: 2 Adelaide Street, Page 36	
Pediment: a triangular section above the door or portico, usually supported by columns. The inside of the triangle is called the tympanum. Example: 380 Catharine Street, Page 43	
Pilaster: a slightly projecting column built into or applied to the face of a wall for additional structural support. Example: 67 Clarence Street, Page 52	

Quoin: masonry blocks at the corner of a wall, often a decorative feature, usually larger or of a different colour than the rest of the wall. Example: 322 King Street, Page 25	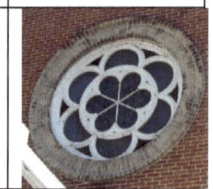
Rose Window: a circular window with ornamental tracery radiating from the centre. Example: 123 King Street, Page 11	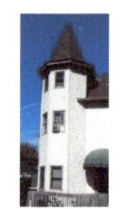
Tower: A circular, square, or octagonal vertical structure higher than the surrounding structure that is usually part of an existing building and is created either for extra defense or for a specific purpose such as a clock or a bell tower. Example: 2 Adelaide Street, Page 36	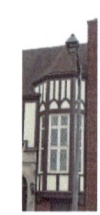
Turret: a small tower that projects from the wall of a building. Example: 72 Charlotte Street, Page 33	
Verge board and Finial: also called bargeboards – hang from the projecting end of a roof and are often elaborately carved and ornamented. **Finial:** ornament added to the top of a gable, pinnacle, canopy or spire – a Gothic element. Example: Charlotte Street, Page 36	

Building Styles

Art Moderne, 1930-1945 – This style originated in the United States with rounded corners, smooth walls, and flat roofs. Large expanses of glass were used, even wrapping around corners. Example: 66 Charlotte Street, Page 35	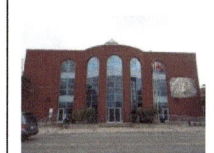
Beaux Arts: Promoters of this style sought to express the classical principles on a grand and imposing scale. Many of the Beaux Arts buildings were banks, post offices, and railway stations. The Ontario Beaux Arts style is eclectic mixing elements of Classical, Renaissance and Baroque. Often the designs have a temple-like façade, porticos with pediments, balustrades, and capitals in many styles. Example: 212 West Street, Page 55	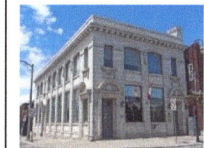
Edwardian, 1900-1930 – This style bridges the ornate and elaborate styles of the Victorian era and the simplified styles of the 20th century. Edwardian Classicism provided simple, balanced facades, simple rooflines, dormer windows, large front porches, and smooth brick surfaces. Voussoirs and keystones are used sparingly and are understated. Finials and cresting are absent. Cornice brackets and braces are block-like and openings have flat arches or plain stone lintels. Example: 28 Erie Street, Page 38	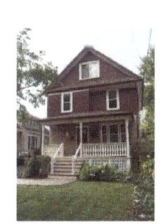

Georgian, before 1860 – This style began with the British King Georges in the 18th century. These buildings have balanced facades around a central door, medium-pitched gable roofs, and small paned windows. Example: 280 King Street, Page 14	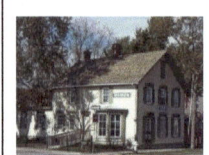
Gothic Revival, 1830-1890 – These decorative buildings have sharply-pitched gables with highly detailed verge boards, pointed-arch window openings, and dichromatic brickwork. It is a common style in Ontario. Example: 350 Catharine Street, Page 47	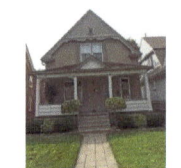
Italianate, 1850-1900 – A two story rectangular building with a mild hip roof, a projecting frontispiece, and generous eaves with ornate cornice brackets was the basis of the style; often there are large sash windows, quoins, ornate detailing on the windows, belvederes and wraparound verandahs. Italianate commercial buildings often have cast iron cresting and elegant window surrounds. Example: 322 King Street, Page 25	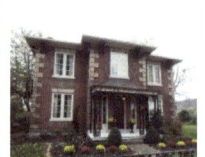

A **log cabin**, built from logs, was usually one- or 1½-storeys constructed with round rather than hewn, or hand-worked, logs, and erected quickly for frontier shelter. Log cabins were built from logs laid horizontally and interlocked on the ends with notches. The cabin was situated to provide sunlight and drainage so the pioneers could cope better with the rigors of frontier life. The pioneers chose old-growth trees that were straight and had few knots and did not need to be hewn to fit well together. The length of one log was the length of one wall. Example: 280 King Street, Page 22	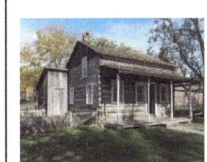
Neo-colonial (also Colonial Revival, Georgian Revival or Neo-Georgian) architecture seeks to revive elements of architectural style of American colonial architecture of the period around the Revolutionary War which drew strongly from Georgian architecture of Great Britain. Architecture from the 18th and early 19th centuries in Ontario includes a wide assortment of detailing and ornament applied to a design centered around the fireplace and the source of water. Structures are typically two stories, have a symmetrical front facade with elaborate front doorways, often with decorative crown pediments, fanlights, and sidelights, symmetrical windows flanking the front entrance, often in pairs or threes, and columned porches. Example: 16 Park Street, Page 49	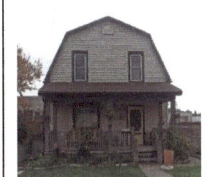

Neo-Gothic: is monochromatic and on a much grander scale than Gothic. Early neo-Gothic churches were often plastered or painted, later neo-Gothic churches were not. An important moment in the development of neo-Gothic is the year 1853, when the hierarchy of the Roman Catholic church was fully restored in the Netherlands. Materials used were natural stone combined with brick. Around the year 1850 neo-Gothicism was maturing and increasingly became a Roman Catholic style almost exclusively. Example: 123 King Street, Page 11	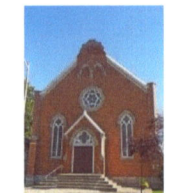
Ontario Cottage - one or one-and-a-half story buildings with a cottage or hip roof. The cottage roof is an equal hip roof where each hip extends to a point in the center of the roof. The hip roof has a long hip in the center. The Ontario Cottage is the vernacular design of the Regency Cottage which generally has a more ornate doorway and a partial or full verandah surrounding it. Example: 57 Erie Street, Page 38	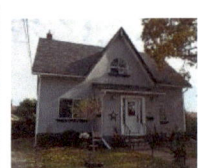
Queen Anne, 1885-1900 – This style is distinguished by an irregular outline featuring a combination of an offset tower, broad gables, projecting two-storey bays, verandahs, multi-sloped roofs, and tall, decorative chimneys. A mixture of brick and wood is common. Windows often have one large single-paned bottom sash and small panes in the upper sash. Example: 2 Adelaide Street, Page 36	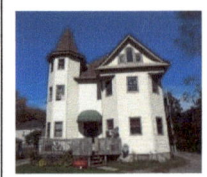

Romanesque Revival, 1880-1910 – This style hearkens back to medieval architecture of the 11th and 12th centuries with a heavy appearance, blocky towers and rounded arches. Example: 380 King Street, Page 27	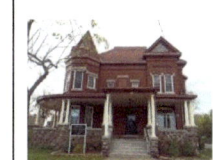
Tudor Revival – exposed timbers with stucco infill, multi-paned windows. Example: 72 Charlotte Street, Page 33	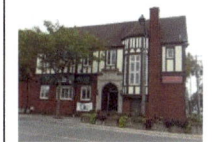
Vernacular/Traditional Mode 1638 - 1950 Influenced but not defined by a particular style, vernacular buildings are made from easily available materials and exhibit local design characteristics. Example: 62 Erie Street, Page 39	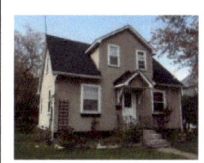
Victorian - In Ontario, a Victorian style building can be seen as any building built between 1840 and 1900 that doesn't fit into any of the other categories. It encompasses a large group of buildings constructed in brick, stone, and timber, using an eclectic mixture of Classical and Gothic motifs. Example: 518 King Street, Page 29	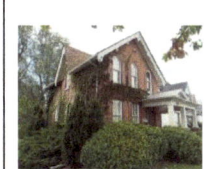

www.ingramcontent.com/pod-product-compliance
Lightning Source LLC
Chambersburg PA
CBHW041105180526
45172CB00001B/113